G000127439

IMAGES
of Wales

CATHAYS, MAINDY, GABALFA AND MYNACHDY
THE SECOND SELECTION

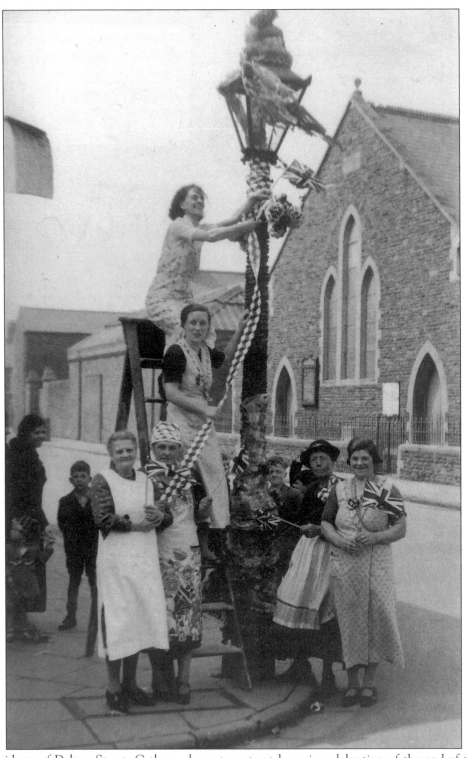

Residents of Dalton Street, Cathays, decorate a street lamp in celebration of the end of the Second World War.

IMAGES
of Wales

CATHAYS, MAINDY, GABALFA AND MYNACHDY
THE SECOND SELECTION

Compiled by
Brian Lee

TEMPUS

First published 2000
Copyright © Brian Lee, 2000

Tempus Publishing Limited
The Mill, Brimscombe Port,
Stroud, Gloucestershire, GL5 2QG

ISBN 0 7524 1889 0

Typesetting and origination by
Tempus Publishing Limited
Printed in Great Britain by
Midway Clark Printing, Wiltshire

This book is dedicated to my sister Valerie and brother-in-law Malcolm

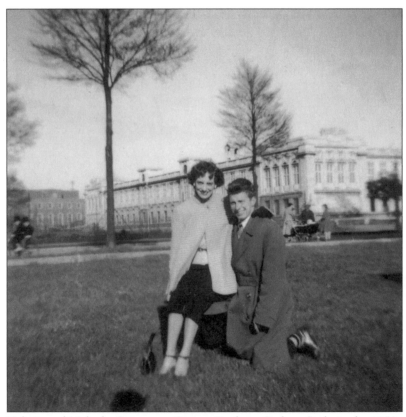

Valerie and Malcolm Beames at Crown Gardens, Cathays Park, in the 1950s.

Contents

Foreword

Having enjoyed Brian Lee's extremely popular first book on Cathays, Maindy, Gabalfa and Mynachdy and the ones on Central Cardiff, I was thrilled to be asked to write a foreword to his new book on the area.

As a young resident of Cathays, the book is as much a learning experience and a history lesson as it is a pleasurable trip in pictures through the area in which I live. And what an interesting past these communities in central Cardiff has to offer.

The new book gives a more detailed insight into the history of the area than the first one, taking the reader on a journey through various aspects in the lives of the residents of these inner city streets, focusing on important landmarks such as schooldays, work and leisure. There are also fascinating detours along the way, which enable us to meet interesting characters as well as those who played significant roles in the communities we visit.

Readers even have the chance to experience historical events, such as VE day and the Queen's Coronation, which were always a good excuse for a street party.

Action pictures almost come alive. You can feel yourself drifting off into the hustle and bustle of community life then – and could almost be a part of the huge crowd as they cheer Cathays' very own Tommy Oldfield to victory in the 1911 Welsh Powderhall Handicap Sprint. It is amazing and, in a way, quite sad that the areas depicted in Brian's new book have changed so dramatically over the years. It is a shame that places like Cathays Terrace Roller Skating Rink, which hosted the very first Welsh National Roller Skating Dancing Championships, are no more.

But despite many considerable changes in Cathays, Maindy, Gabalfa and Mynachdy over the past century, there are several elements of these areas' fascinating history which still remain. Many people are still loyal customers of Summerhayes butchers in Wyverne Road, Cathays, and the Flora Hotel, in Cathays Terrace, will always welcome its regulars.

And it must not be forgotten that Cathays, Maindy, Gabalfa and Mynachdy are important areas in the modern history and development of Cardiff, with Cardiff University being one of the focal points. Student life will help ensure that these areas of the city remain lively and prosperous for years to come.

So, all that is left for me to say is thank you to Brian Lee for a book which presents Cathays, Maindy, Gabalfa and Mynachdy in many interesting, and sometimes surprising photographs. I am sure this new book will bring happy memories of times past to long-time residents and to those who have known the area for years, as well as providing an insight into Cardiff's history for younger generations.

Emma James
Reporter for the *South Wales Echo*

Introduction

When I compiled the first Cathays, Maindy, Gabalfa and Mynachdy book I had no idea that it would prove so popular. It sold 900 copies in the first two weeks and made the *Western Mail's* top ten bestseller list two weeks running. Who would have thought that a book containing old photographs of the above areas would figure on the same list of books, mostly fiction, written by authors such as Trollope, Ackroyd, and Cornwell?

In compiling this second selection, I have been lucky in as much as I have had a bigger response to my requests in the local press for readers photographs than I had when compiling the first selection. Proof, if needed, that more and more people are discovering the pleasure to be gained from the study of these pictures of yesteryear in *The Archive Photographs* Series of books.

This year, 2000, sees Gladstone School celebrating its centenary and included are a number of school photographs spanning around fifty years. Some of the photographs in this second selection show houses, schools or buildings that are now long gone. For instance, there are some rare pictures of the terraced houses that used to be in Flint Street and Cross Street and the people who once inhabited them. I wonder how many Cardiffians know that Minny Street in Cathays is spelled Minnie Street at the Cathays Terrace end, and Minny Street the Woodville Road end. The Welsh Congregational chapel, established in 1884, has Minny Street engraved in stone over its main entrance door and as the ordnance plans since 1898 refer to it as Minny Street this seems to be the more accepted version.

Having lived the first thirty years or so of my life in Cathays, I certainly have many happy memories of the area. The girl I was to marry, Jacqueline Bryant, also lived in Cathays or upper Cathays as she would have it. My wife went to Gladstone School in Whitchurch Road and it was the nearby Carnegie Cathays Branch Library that had a big influence on my life. One of two branch libraries presented to Cardiff by Andrew Carnegie, it was opened on 7 March 1901 and was erected at a cost of £5,356. Many is the hour I spent in the fine children's reading room and it was in this wonderful hall of enlightenment that I discovered the thrilling *Biggles* books and those brilliant *Just William* stories.

The classic *Black Beauty* and another book called *Beautiful Joe*, about a stray dog, moved me to tears. Later, when I was much older, it was the novels of Jack Jones and Henry Williamson that brought tears to my eyes. Little did I think then that one day my own books would be in the library or that I would be asked to give a talk to local schoolchildren there after the first Cathays book was published in 1998.

Some of the photographs in this book are of the many street parties that were held after the Second World War. My earliest childhood memories are of the war and the Anderson air-raid shelter at the bottom of our garden in Thesiger Street. Crouched below our earth-topped, reinforced hideout my mother, my sister Valerie and I would be able to tell their aircraft from

ours by the sound they made. The damp smell of that air-raid shelter is something I will never forget. There used to be a chimney sweep in our street who used his air-raid shelter to dump all the soot he collected. He had a large family who usually stayed indoors during the bombings. One particular night, with it being a rather heavy air-raid, they had no alternative but to jump down into the shelter for cover. When the all clear siren was sounded they emerged unscathed, but covered in soot! During one air-raid, my Aunt Sarah, cousin Valerie, my mother and I were at our local cinema, the Coronet, when the air-raid warning siren was sounded. In the dark and confusion that followed my mother got outside the cinema to find she was holding the hand of the wrong boy!

They were hard and sometimes sad times to have lived through. And there were no counsellors around in those days to help those who had lost loved ones during the war, yet one feels privileged to have lived during such a historic time.

I have managed to obtain a good selection of end of the war street party photographs which will be of great interest to those who, like myself, can just about recall the Second World War and the street bonfires we had at the end of the hostilities. Those of you too young to remember those days will probably come across photographs of your grandparents, parents, uncles or aunts taking part in those unique celebrations. While some of you will recognize in the ensuing pages long forgotten faces that will bring forgotten memories of people and past scenes flooding back. I hope most of those memories will be happy ones.

Brian J. Lee

One
Trades and Traders

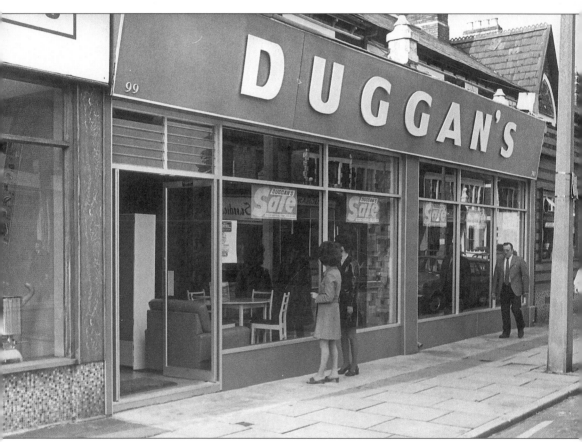

Duggan's Furniture Stores, Woodville Road, Cathays, October 1972. The gentleman wearing a tie is Vic Davies, the then proprietor of the Superline garage and petrol station in Woodville Road. The lady on the left is Lynne Ingram and the lady on the right is Val Welsh.

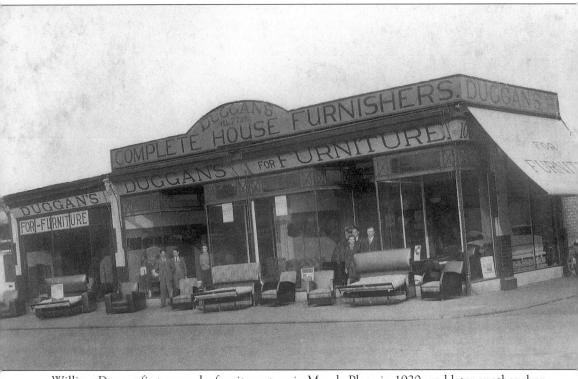

William Duggan first opened a furniture store in Mundy Place in 1920, and later another shop in Whitchurch Road. As the firm expanded they moved to these larger premises in Woodville Road before the start of the Second World War. The business is now known as the Blue Lamp Club.

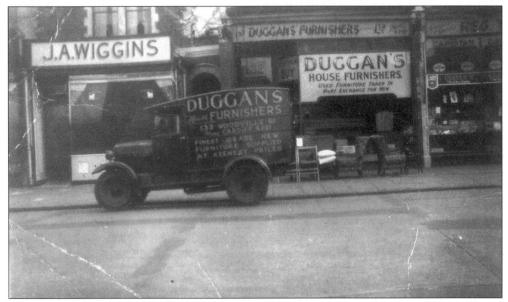

The Trojan van, seen outside Duggan's Furniture Stores, c. 1947, was bought just after the war from Brooke Bond Tea Company and was powered by a twin-stroke engine. Jack Wiggins's butcher shop is to the left of picture and Reg Young barber's shop to the right.

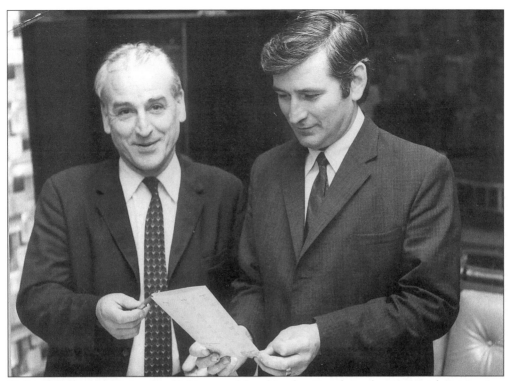

Colin Duggan and his brother Robin posed for this photograph in the upstairs showrooms at 99-101 Woodville Road, c. 1970.

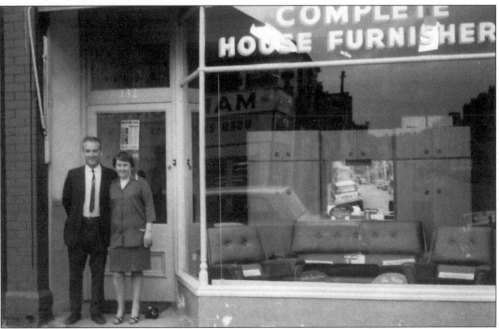

This picture of Colin Duggan and his wife Eileen was taken outside their shop at 132 Woodville Road in 1960. The shop was previously a fish and chips shop. Note the reflection of the motor car in the mirror of the bedroom suite.

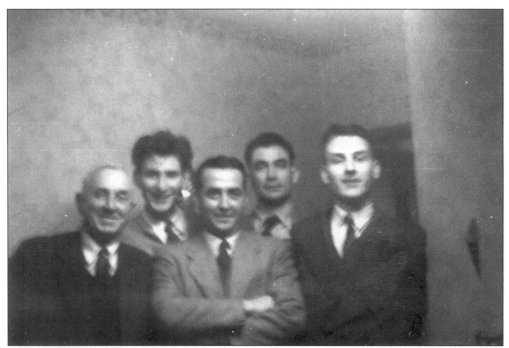

William Duggan left with four of his five sons – left to right: Vivian, Colin, Robin and William – who were all at onetime employed in the business.

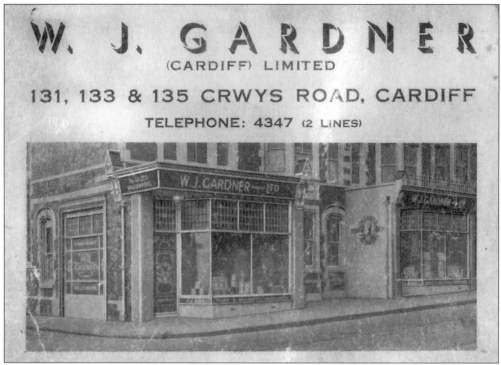

W.J. Gardner, Crwys Road. Established in 1910, this paint and decorating store is still family owned under the directorship of William James Gardner's great grandson Philip.

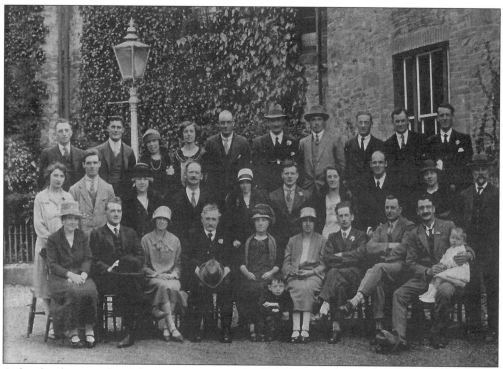

A family photograph of the Gardner family. William James Gardner, who started the home decorating business, is fourth from the left in the front row.

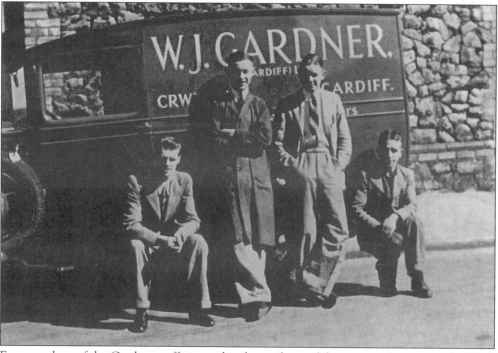

Four members of the Gardner staff pictured in front of one of the company's vans, c. 1944. Left to right: Alec White, George Ocock. The other two are unknown.

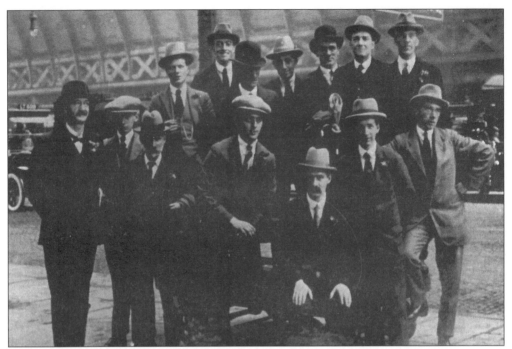

An outing to London was organized in the 1920s for these staff members of W.J. Gardner. The photograph was taken at Paddington station.

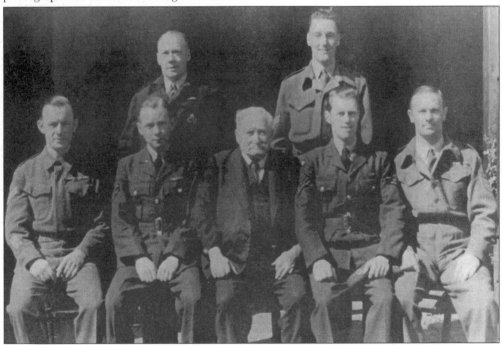

W.J. Gardner had this photograph taken with his sons Harold and Alan and four other members of his staff during the Second World War. Standing left to right: Harold Gardner and Eddie Pagler. Left to right, seated: George Ocock, Alan Gardner, W. J. Gardner, Alec White, Billy Llewellyn.

14

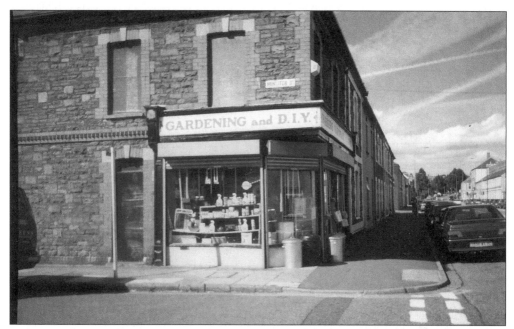

Parkers Gardening and DIY store in Cathays Terrace sadly closed in 1999. It was previously a grocery store (see photographs in first selection of Cathays, Maindy, Gabalfa and Mynachdy book).

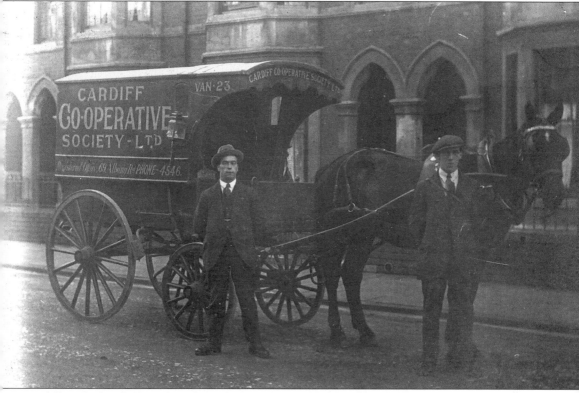

Cliff Nicholas (left) and Arthur Clark (right) both of Cathays worked as milkmen for the Cardiff Co-Operative Society Ltd in the 1920s.

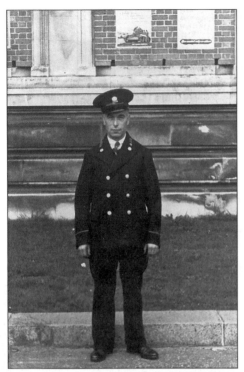

Bus conductor Cliff Nicholas had the surprise of his life in November 1936 when Mrs Violet Hoare, wife of Ely labourer George Hoare, gave birth to a baby boy aboard his bus. He cleared the bus of its passengers and ordered the driver to dash to hospital. The bottom picture shows Mr Nicholas (left) and his driver Eddie Job (right). Mr Nicholas ended up as an inspector as the picture to the left shows.

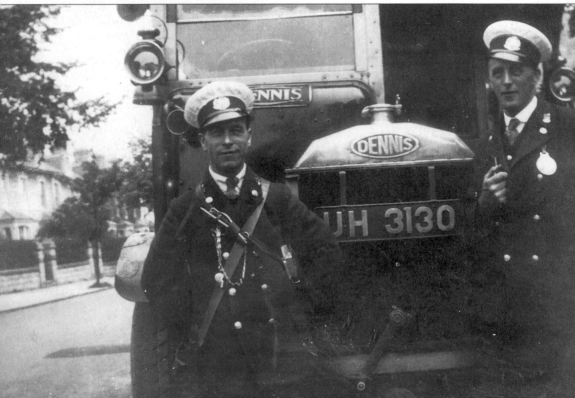

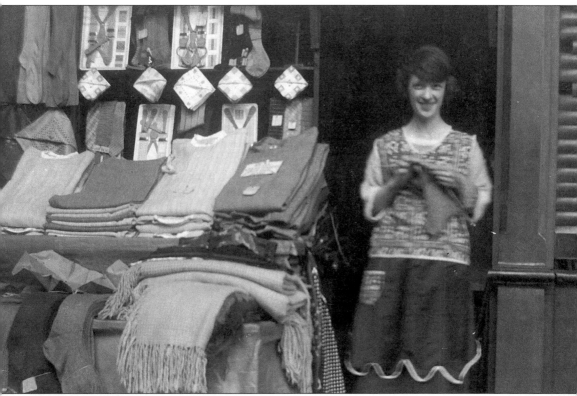

During the 1920s, Dorothy Hamley of Flora Street, Cathays, later to become the wife of Cliff Nicholas, worked for Mrs Montrose's haberdashery in Cardiff's Central Market.

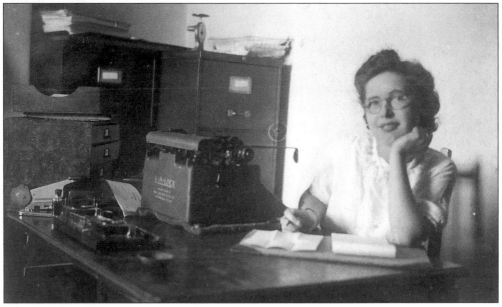

Dulcie Vincent, née Nicholas, of Cathays, a former pupil of Gladstone School, worked as a secretary for the Welsh Association of Boys' Clubs in the early 1950s. She is the daughter of Dorothy Nicholas as seen in the above picture.

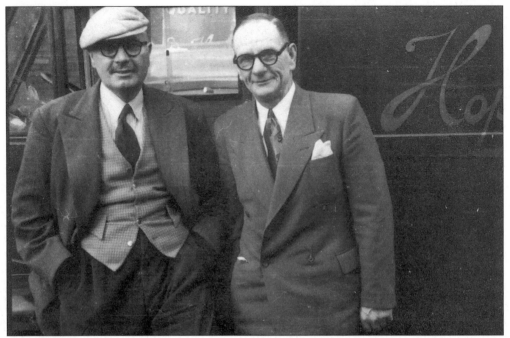

Gwyn Povey and Jack Reid who worked at Hopkin Morgan Bakery which was situated on the North Road junction with Western Avenue. Mr Povey looked after the horses and Mr Reid was a supervisor.

Hopkin Morgan Bakery staff, c. 1950. Left to right: Phoebe Smurthwaite (dispatch department), Betty Walters (office), Monica Walsh (office), Gwyn Povey (stable-man and later electric vehicle driver), -?-, -?-, Molly Vincent (office). The young man seated in front is Philip Rich son of the office manager Norman Rich.

Brinley Lewis, from Cathays, worked as a bus cleaner at the Red & White bus depot in Gelligaer Street at the rear of Maindy Stadium. He retired in 1974 and died five years later. The picture of the bus depot below was taken in December 1986. The building has not been used for some years.

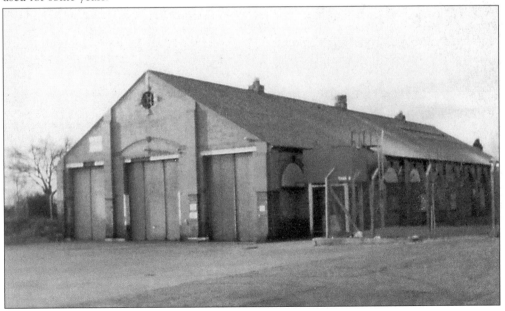

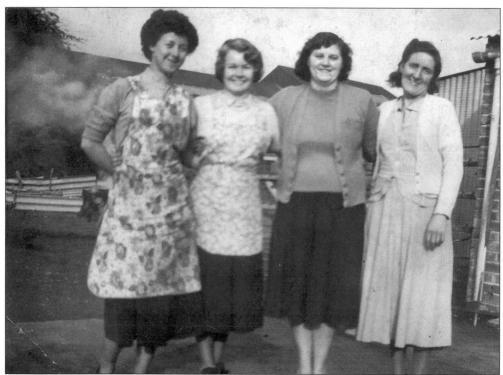

Joan Burnell, née Goodall, (second left) from Cathays, worked at Marcus Goldblatt's shoe factory in Maes-y-Coed Road. Pictured left of her is May Grainger and right Shirley Davies. Mabel ? is on the extreme right, *c*. 1950.

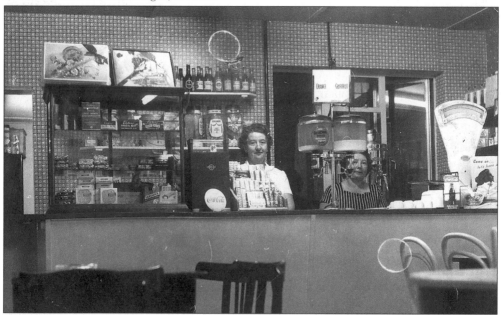

Marion Bate pictured right was manageress of the Embassy Roller Skating Rink café in Cathays Terrace. Assistant Betty Kane can be seen to the right of her. Many people will remember the Punch and also the Crunchie chocolate bars seen displayed directly in front of Mrs Bate, *c*. 1951.

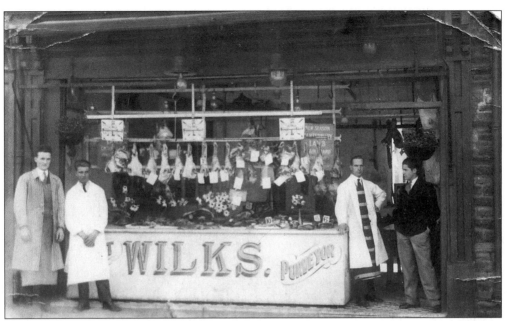

The young man second left is Henry Summerhayes who started his career as a butcher at Wilks in Clifton Street. In around 1947 he opened his own business in Wyverne Road, Cathays, which is son Robert, seen below, took over in 1968.

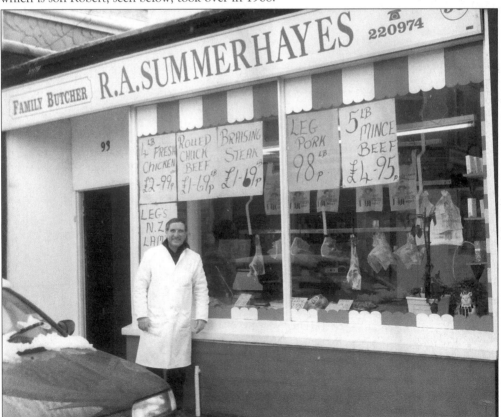

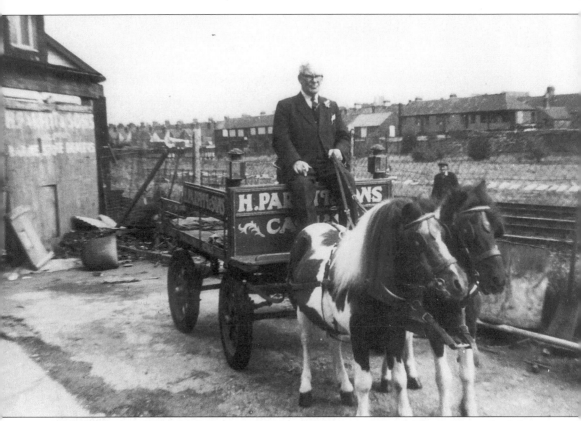

The well-known Harry Parfitt outside his Norman Street scrapyard. The pony on the left was called Winkie and the one on the right Foxy, *c.* 1962.

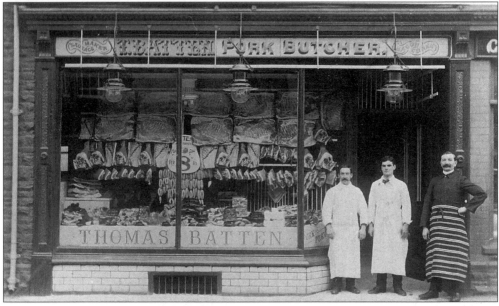

Thomas Batten, extreme right, had three butcher shops in Salisbury Road in the 1920s and they were all as well stocked as this one pictured here.

George Badman in Mynachdy Road with his greengrocery cart in 1937.

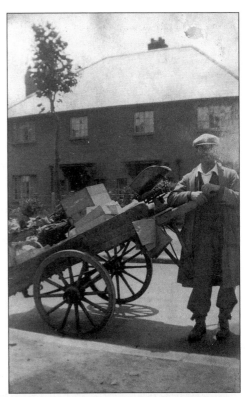

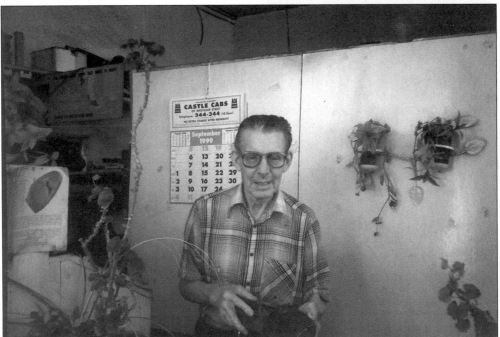

Norman Cook seen here in his Minister Street workshop has been repairing the shoes of local inhabitants for more than forty years. This picture was taken by the author in the September of 1999 as can be seen by the calendar in the background.

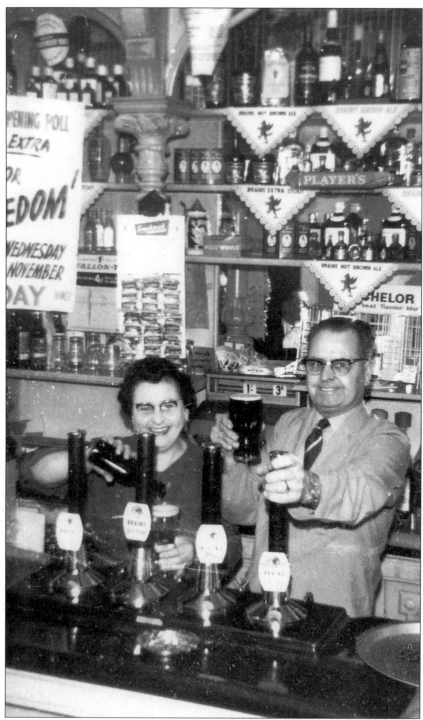

Tommy and Lily Williams mine hosts at the Flora Hotel in Cathays Terrace. The poster to the left of the picture is inviting patrons to vote in the 1961 Referendum on the Sunday opening of pubs in Wales. Note that the till behind them has rung up 1s 3d. About the price of a pint in those days!

Bob Plain, of Pen-y-Bryn Road, Gabalfa, worked as a sales representative for Hobson & Son Wholesale Tobacconist for around fifty years. He is seen here leaning on his Austin A 40 van. He retired in 1986 when the company finished trading.

Great Western Railway train driver Bill Stamp (standing fourth from the right, wearing a light coloured suit) and his work mates posed for this picture at the Cathays railway work sheds in the late 1940s. His good friend Jim Young can be seen to the right of him smoking a pipe.

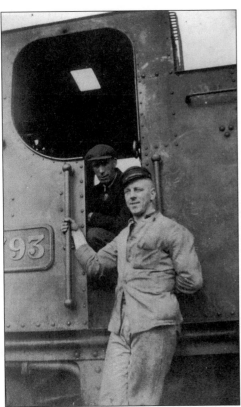

Bill Stamp, who lived in May Street, Cathays, pictured standing outside his train. The man in the cabin is unknown, *c.* 1948.

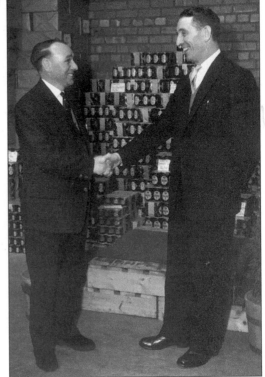

George Thomas (right), MP for Cardiff West and later to become Speaker of the House of Commons in 1976, is seen shaking hands with Idris Bateman at the opening of Bateman Welsh Grocers at Maindy in 1960.

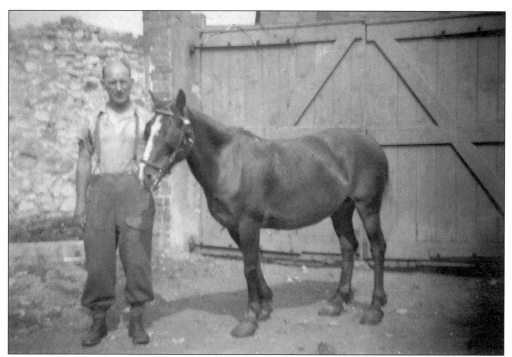

Mynachdy's George Badman who sold fruit and vegetables from his horse and cart is seen here with his two mares Kath and Daphne, c. 1949. He had his stable at the back of the Machen Forge public house in Blackweir.

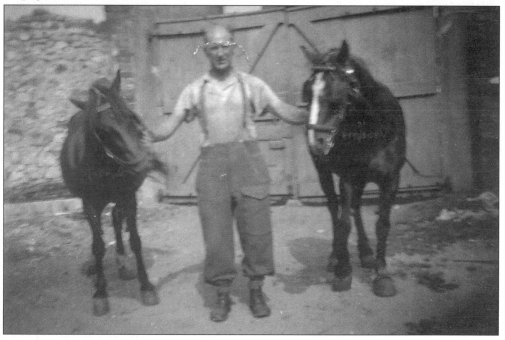

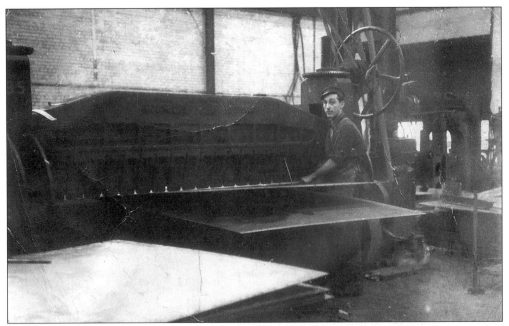

Tom Badman, of Mynachdy, working the bending machine at the Cambrian Wagon Works, Maindy, *c.* 1948.

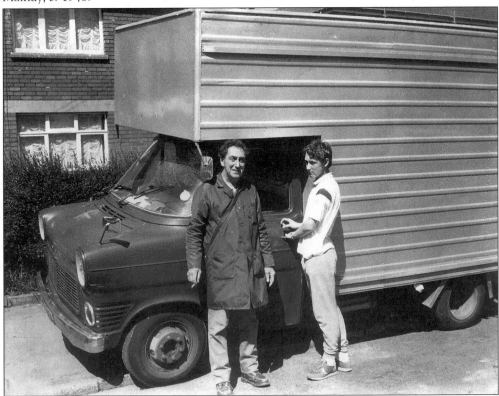

The same Tom Badman who later in life had a mobile greengrocery van. He is seen here with his grandson Russell Rowley in Appledore Road, *c.* 1980.

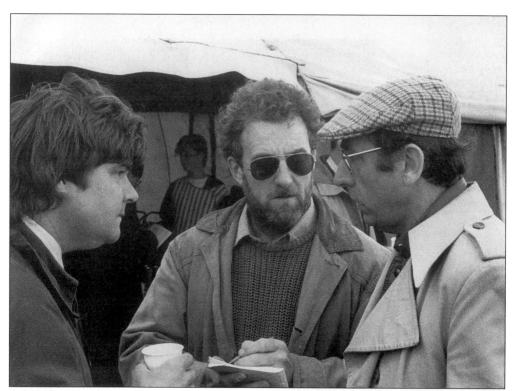

Author Brian Lee, right of picture, lived in Cathays for more than thirty years and has been reporting on the local point-to-point scene since 1966. He is seen here interviewing film actor Bernard Hill who played the captain of the ill-fated Titanic in the blockbuster movie of the same name. Racehorse owner Gordon Lewis is left of picture, *c.* 1985.

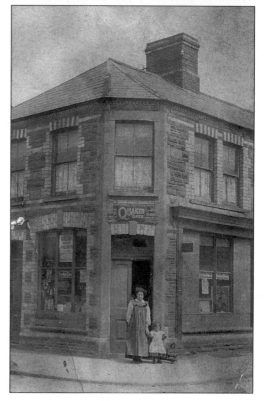

The lady who ran this May Street general store was Mrs Clara Ann Lewis and the little girl holding her hand is her daughter Florence, *c.* 1885.

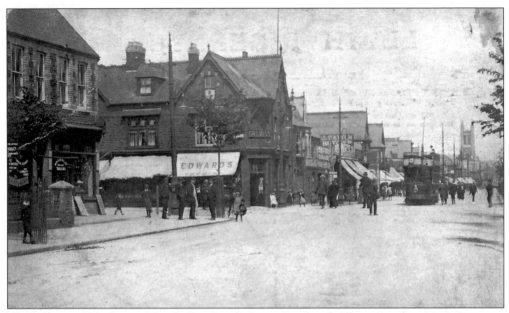

The junction of Richmond Road, City Road, Crwys Road and Albany Road, *c.* 1904. For more than 100 years the above roads have been the main local shopping area for those residents of nearby Cathays.

Thomas Goman, of Dalton Street, Cathays, worked for the Cardiff Corporation Transport Department as a tram driver for around twenty years and is seen here around 1938.

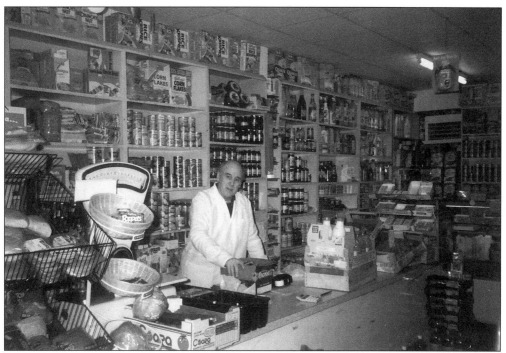

Many corner grocery stores have had to 'fold up' since the advent of supermarkets. But one of the few still holding out against tremendous competition is Sid Eggar's well-stocked general stores in Brithdir Street, Cathays. Mr Eggar had been serving local customers for more than forty years by the end of the century.

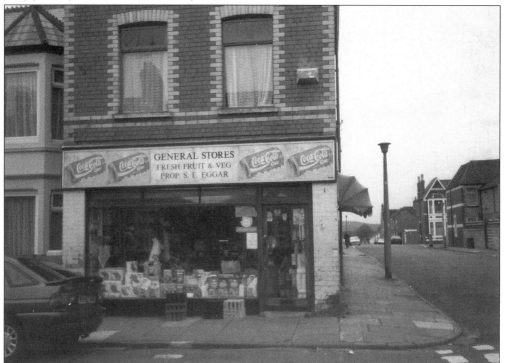

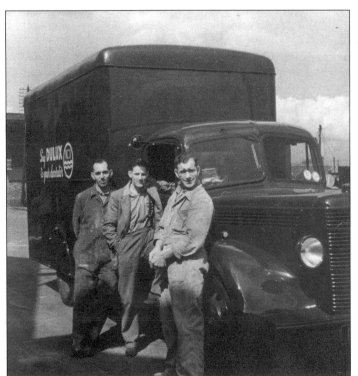

Robert 'Bob' Jones (first left), of Gabalfa, who worked for ICI is seen here with two of his workmates, *c.* 1950.

Many people will remember the pram shop owned by Georgina May Cole in Crwys Road, Cathays. The picture was taken in 1958 when prams were more fashionable than they are these days.

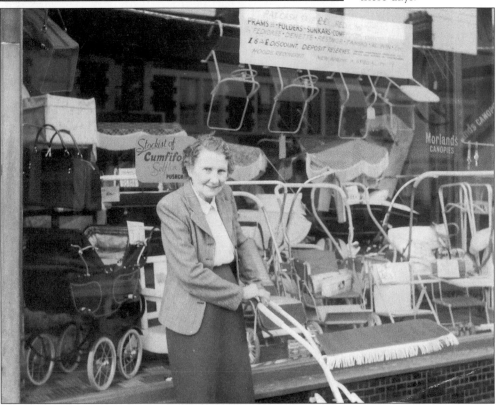

Before the last war, Ivor Winter (above)
from Cathays and his brother Clem
(below),who owned a local farm dairy,
won many prizes at local horse shows with
their milk round horses.

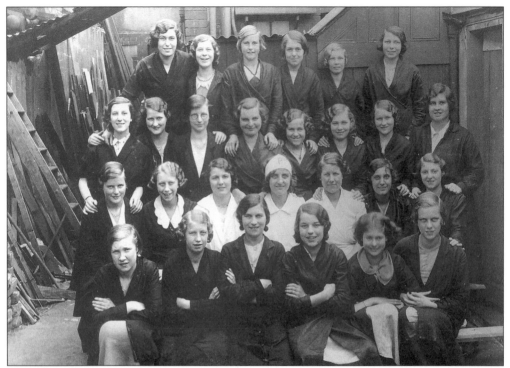

Peacocks staff at the rear of the shop in Woodville Road, Cathays, *c*. 1929. Doris Stamp, a sister of Bill Stamp (see p. 26), is second left on the second row from the front.

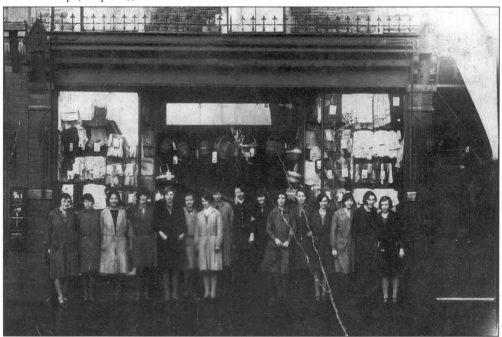

Peacocks Woodville Road staff seen during the 1920s. On the wall to the left of the picture is a Cadbury's penny chocolate bar machine. Although the shop was known as Peacocks, it was actually owned by Ernest Charles Rayer who bought all his stock from Peacocks.

Two
People and Places

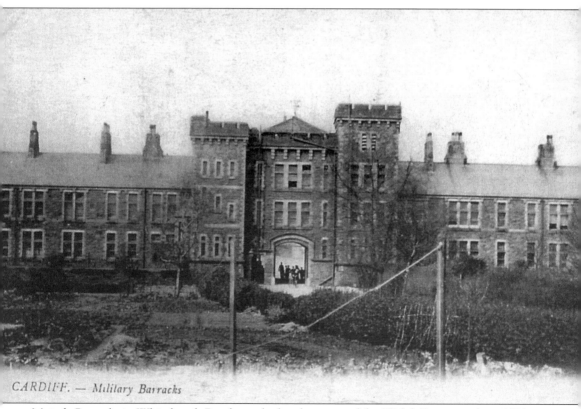

CARDIFF. — Military Barracks

Maindy Barracks in Whitchurch Road was the headquarters of the Welch Regiment from 1881 until 1960.

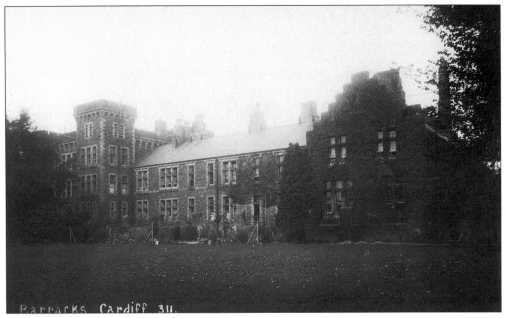

Another view of Maindy Barracks, *c.* 1900.

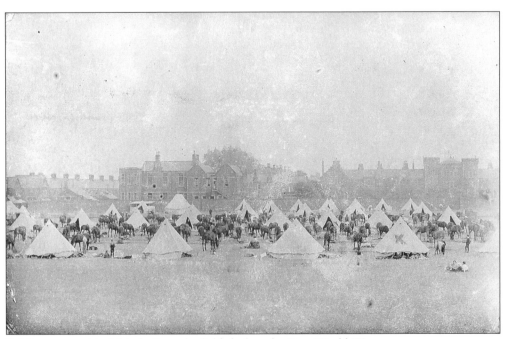

Soldiers camped in Maindy Barracks fields before the First World War.

The Welch Regiment Cenotaph is situated beside the entrance drive to Maindy Barracks. Made from Portland stone, it is similar to the much bigger Cenotaph in London's Whitehall.

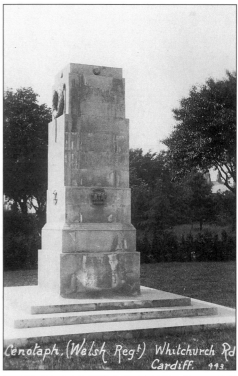

Cenotaph. (Welsh Regt) Whitchurch Rd Cardiff. 443.

Until recently, just up the road from Maindy Barracks was St Joseph's Roman Catholic School. Two of its well-known teachers of the 1940s were Miss McCarthy (wearing a turban) and Miss Muggrave (to the right of her). Among the pupils in this photograph taken at Porthcawl School Camp are: Maureen Davies, Eileen O' Leary, Nora Sullivan, Dorothy Williams, Mary Corbett.

Between 1926 and 1934, some 16,000 cart loads of house rubble and rubbish were tipped into Maindy Pool after a number of children and adults were drowned there.

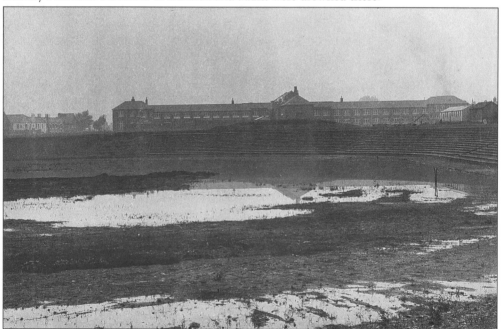

Cathays High School can be seen in the background of Maindy Pool, which was later to become Maindy Stadium.

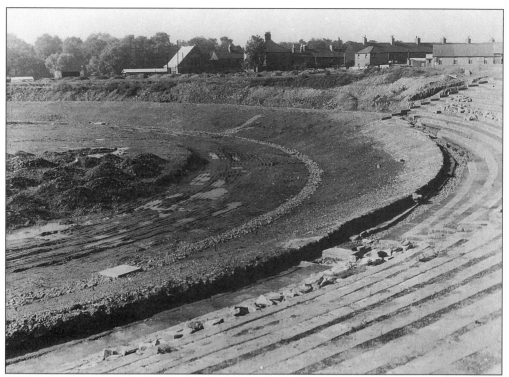

Above: Work had started on changing Maindy Pool into Maindy Stadium when this picture was taken. *Below:* The finished version in 1951 when a large crowd turned up to watch an athletics meeting.

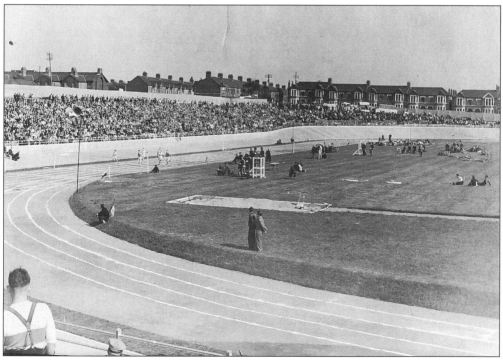

Ron Creed (left) and Val Williams (centre) play acting in the garden of 113 Cathays Terrace in the 1950s. These days Val Williams, now Val Croot, is a well-known medium and spiritualist.

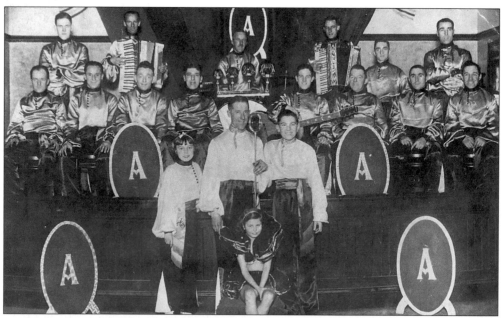

Joan Williams, Val Williams's sister, is the little girl seated who danced with Albertini's Super Harmonica Band in the 1930s. This popular band won the Welsh Dance Band Championship in 1938.

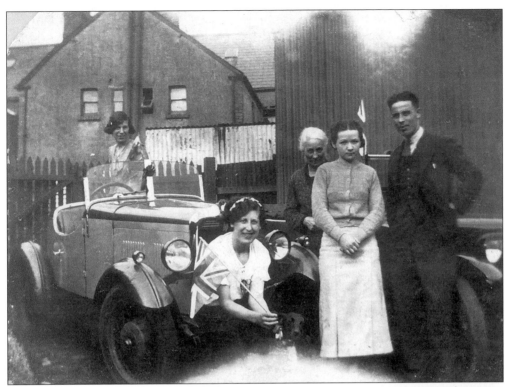

The Singer sports car in this picture once belonged to the famous Welsh boxer Jimmy Wilde. Gwyneth Jones is sat on the bumper holding the a flag. Her sister Dolly is sat inside the car and the others are, left to right: Gwyneth's mother, her brother David and his wife Kitty. The picture was taken behind the Jehovah's Witness Church off North Road in 1937.

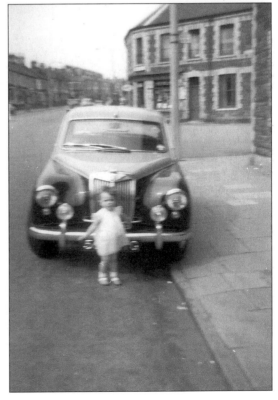

The MG Magnet car outside the Flora Hotel in Cathays Terrace belonged to the landlord Tommy Williams. The little girl is his granddaughter Debbie Croot, *c*. 1958.

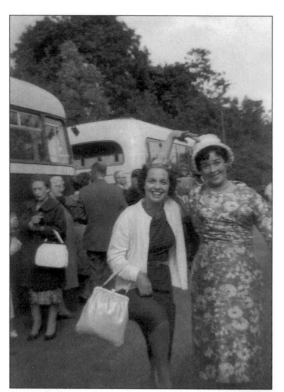

The Flora Hotel organized a number of coach trip outings in the 1950s for its regulars. On this occasion it was a trip to Bath races and Joan McGinnis (left) and Beryl Goss (right) seem to be having a swinging time.

Among the happy race-goers in this picture are Tommy Williams, Lily Williams, Bobby Williams and Tony McGinnis.

Lilian Detorres, of Moy Road, who later became Lily Williams of the Flora Hotel, c. 1922.

Hazel Williams (left) and Val Williams (right) posed for this picture at Barry Island in the 1950s. Hazel Williams, who lived in Flora Street, later became Miss Wales and was known professionally as Beth Owen.

St Michael and all Angels Church, Whitchurch Road. The tin built building above was demolished shortly after this picture was taken in 1996 to make way for the smart new brick built church below.

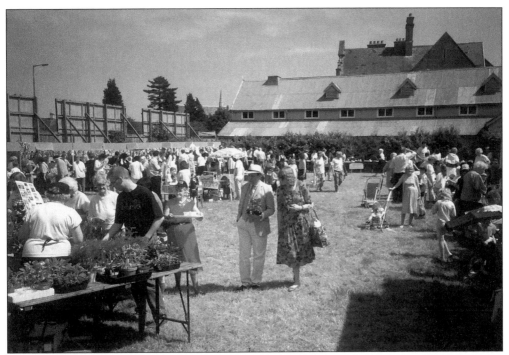

In 1994, St Michael and all Angels Church held a garden party on the site where their new church was later built. The old church can be seen in the background.

Harry Parfitt seen here in Monthermer Road with a group of ladies about to embark on a church outing to Torquay, c. 1966.

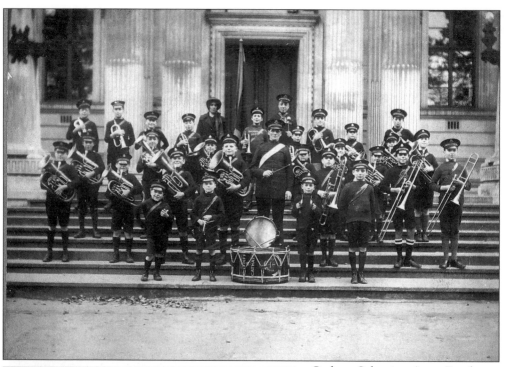

Cathays Salvation Army Band, *c.* 1920. The boy second from the right is Bill Stamp who later worked for the Great Western Railway.

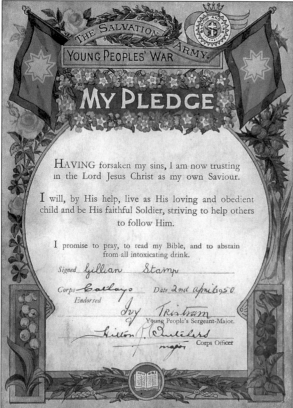

Gillian Stamp, Bill Stamp's daughter, signed the Salvation Army's Young Peoples' War My Pledge on 2 April 1950.

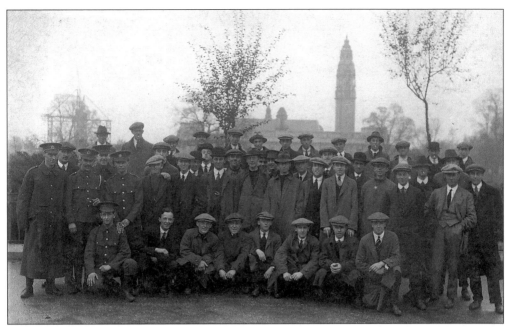

The City Hall (in the background) which was officially opened in 1906 had not been completed when this picture showing soldiers and volunteers from Maindy Barracks was taken. The odd man out is the gentleman second left front row: he's the only one not wearing a hat or cap!

Polling day in Flint Street in the 1950s. Mrs May Rice is the lady holding the reins of the donkey. Cathays High School is the building to the right of the picture.

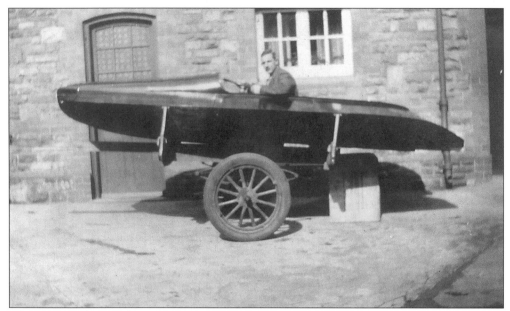

Alf Cowdry, who lived in Flint Street as a young boy, is seen in a speedboat which he made himself in June 1931.

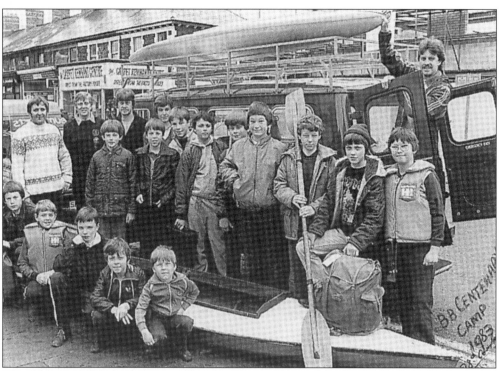

The 28th Cardiff Company Boys Brigade, Woodville Road, preparing to leave for company camp at Saundersfoot in 1983.

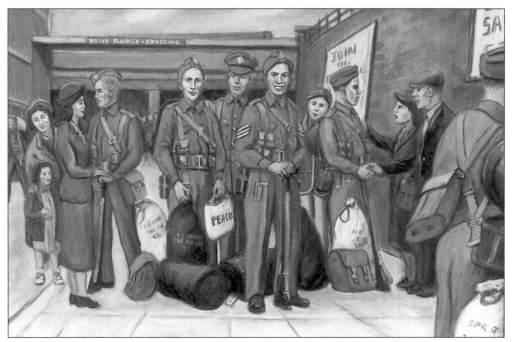

One of the hundreds of paintings by Merthyr Street artist Jack Sullivan. Since 1942 he has had around 200 exhibitions in Britain and abroad. This one shows soldiers from the Cathays area leaving Cardiff to join their units. Mr Sullivan has made around 1,000 visits to local schools showing his paintings which depict Cardiff's historic past.

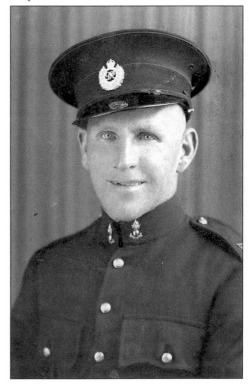

Gordon 'Tac' Coakley, depicted in the above picture above carrying a Peacocks shopping bag, lived in Richards Street, Cathays. The photograph of him pictured in his Royal Engineers uniform was taken in September 1939. He played rugby league for Hull before the war, but sadly had a leg amputated after battle injuries sustained at Dunkirk.

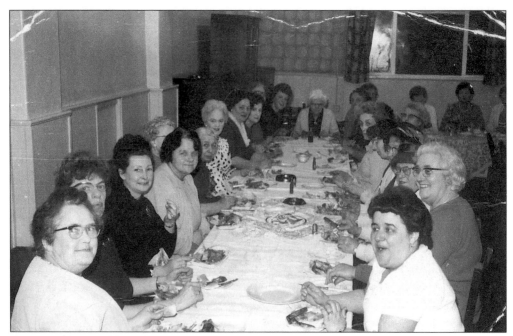

Cathays Labour Club ladies enjoying a Christmas lunch in May Street Hall, *c.* 1952. Among the ladies are: Mrs Lewis, Mrs Bearle, Mrs Burton, Mrs Edith Goman, Mrs Spry and Mrs Partridge.

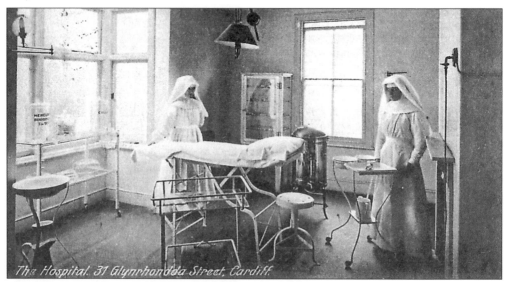

The Bute Hospital for women was at 31 Glynrhondda Street, Cathays. It was run before the First World War by the Sisters of the Sacred Heart of Jesus.

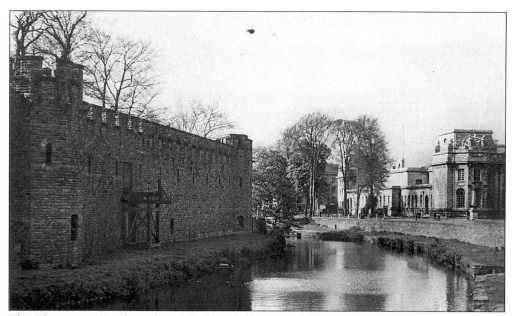

The Glamorgan Canal ran from Merthyr Tydfil to Cardiff Docks: a distance of 25 miles. From North Road it followed the path of the old town wall and moat. On the east side of Cardiff Castle it flowed under Kingsway. The last barge travelled down it in 1942 and the canal was filled in shortly afterwards.

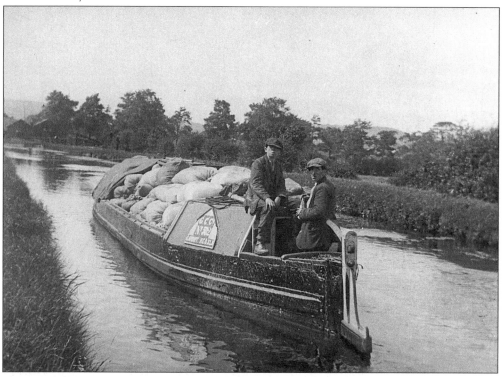

St Joseph's RC club outing to Southsea in the 1950s. Anne Regan, Joan O'Brien, Helen Vick, Dan O' Brien, Tommy Regan and Morris Cody were among those who made the journey.

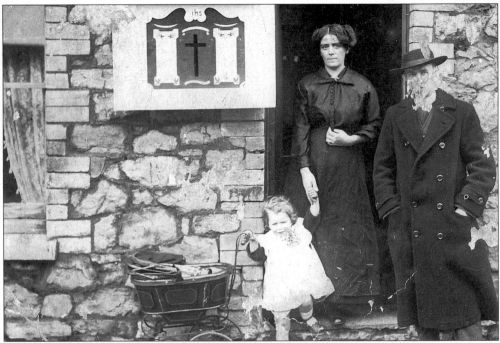

In Cross Street during the First World War, a Roll of Honour naming all those from the street who fell in battle was placed outside this house. Bessie Fergusson and her daughter Molly are seen on this sadly damaged photographs accompanied by the curate of St Marks church in North Road, c. 1916.

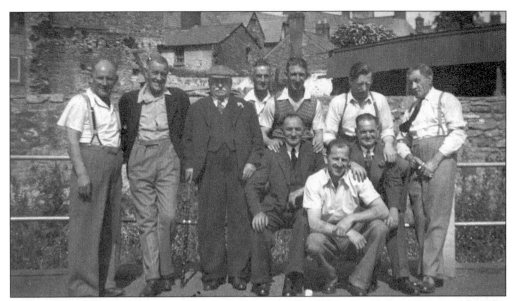

Cathays Conservative Club members on an outing in the 1950s. First left is 'Tac' Coakley who played rugby league football for Hull before the Second World War. Among the others in the picture are: Arthur Parfitt, Reg Wedmore, Jackie Nurse, Jim Connolly and Harry Riseborough.

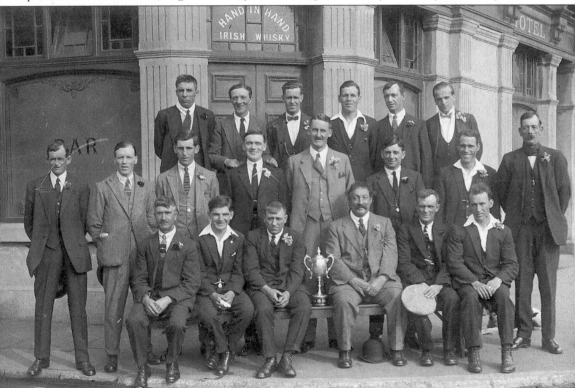

This picture was taken outside the Maindy Hotel public house in the 1920s. Seated to the right of the trophy, won by the pub's members skittle team, is Harry Badman. His son George is seated extreme right. Others in the picture are Mr Lansdowne, Tom Wilkins and Jack Ursell.

Members of Cathays Conservative Club aboard a Campbell's steamer to Ilfracombe in the 1950s. The man in the open neck collar third from the left standing is William Duggan who had a furniture shop in Woodville Road.

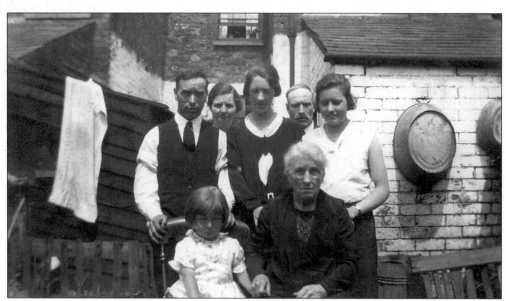

This picture of the Nicholas family who lived at 62 Flora Street, Cathays, was taken in 1932 after the funeral of Clifford John Nicholas who died aged six months. The little girl seated is Dulcie Nicholas. Note the tin baths on the wall right of picture.

The little boy in front of the old Austin motor car is Bernie Plain who grew up to become one of Wales's greatest long distance runners. In the background can be seen St Marks church institute hall in Whitchurch Road demolished in 1967 to make way for the new flyover, c. 1948.

During the 1960s Mrs Bessie Davies (far right), a parishioner of St Joseph's Roman Catholic church, received the papal medal for her services to the church's choir. She is seen here (wearing her medal) with her second husband George Davies and Mrs Parker.

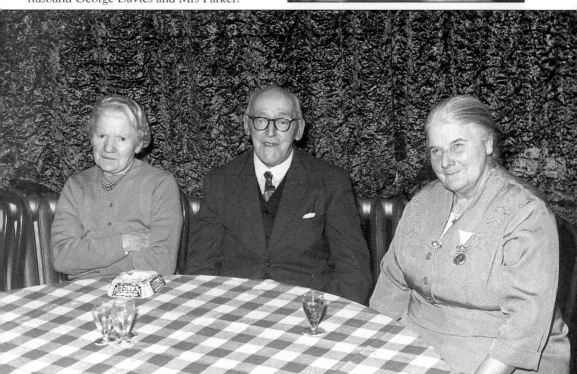

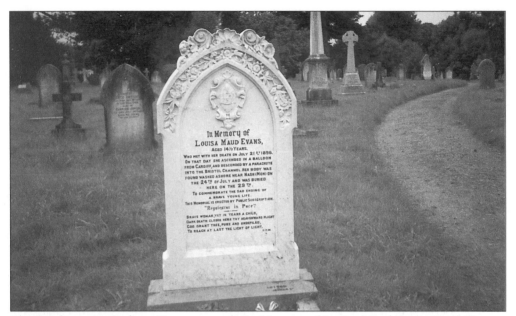

This headstone in Cathays Cemetery reads 'In Memory of Louisa Maud Evans Aged 14 years who met her death on July 21st, 1896. On that day, she ascended in a balloon from Cardiff, and descended by a parachute into the Bristol Channel. Her body was found washed ashore near Nash (Mon) on the 24th day of July, and was buried here, on the 29th. To commemorate the sad ending of a young life, this memorial is erected by public subscription.'

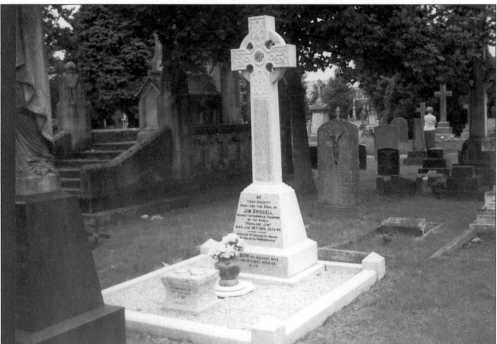

The grave of Peerless Jim Driscoll acknowledged as one of the greatest boxers of all time. His funeral took place in February 1925 and 100,000 people are said to have lined the streets to watch the funeral procession.

The upstairs 'club room' in the Flora Hotel, Cathays Terrace, was used for a number of functions between 1955 and 1962 when Tommy Williams was the landlord.

The Flora Hotel, which dates to back to 1881, originally had stabling facilities for three horses. It is seen here around 1955.

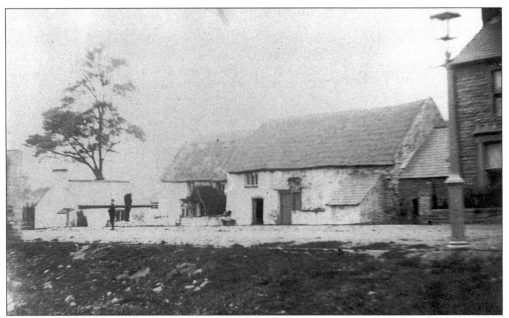

Grange Farm, Llantrisant Street, Cathays, *c*. 1890. It was situated the west end of the street and demolished in 1899. William Davies is believed to have been the last tenant.

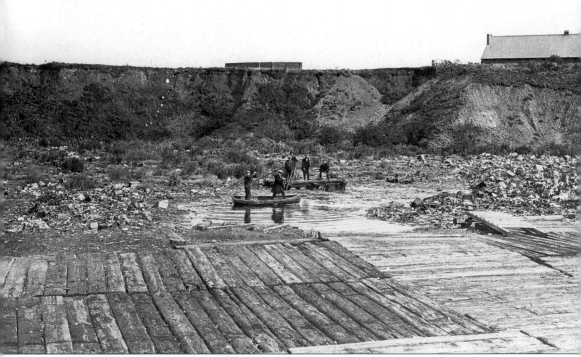

This picture of the notorious Maindy Pool was taken on 27 August 1928. In 1919 a young lad was drowned in the pool and despite a prolonged search his body was never recovered. By 1937 the pool had been completely filled in.

Mr and Mrs Colley of Thesiger Street, Cathays, prepare to pull out the flowers in their garden and join in the Dig For Victory campaign. During the Second World War, civilians were asked to grow vegetables instead of flowers to aid the war effort.

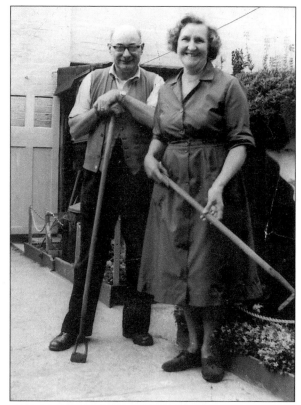

ARPs posed for this picture at Maindy Pool during the Second World War. The three men seated in the centre are Tom Harvey, Percy Cornish and Les Merrick. Cyril Pitman, who had a bicycle shop near the entrance of Maindy Barracks, is also somewhere in the picture.

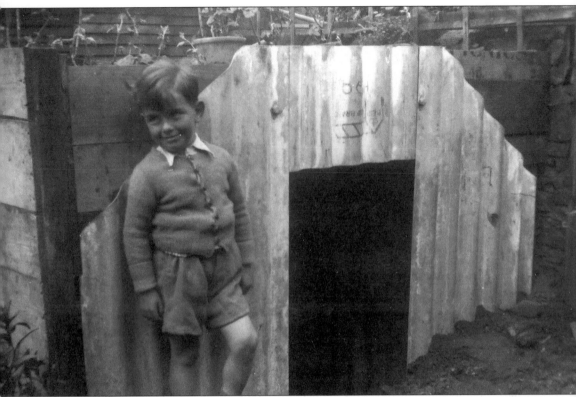

Five-year-old Colin Merrick, of Brithdir Street, Cathays, outside the Anderson air raid shelter in his garden in the summer of 1940.

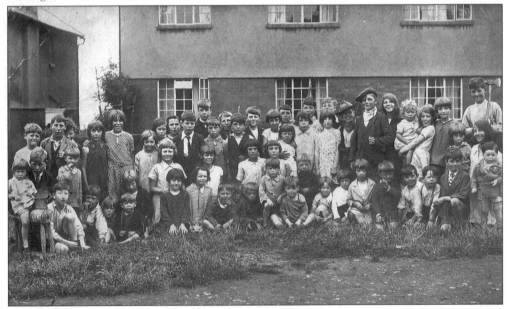

A photograph of children from Parkfield Place, believed to have been taken during the Festival of Britain celebrations in 1951. Note the boy with the dangerous looking axe on the extreme right of picture.

Three
Schooldays

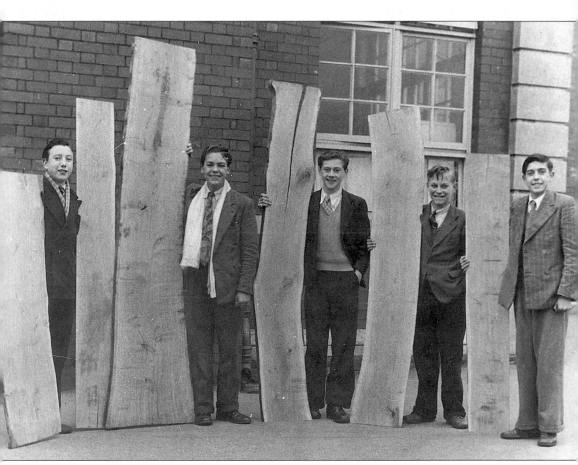

Senior boys at the Viriamu Jones Boys School with the six planks of rough oak which they were to make into a lectern for the school hall.

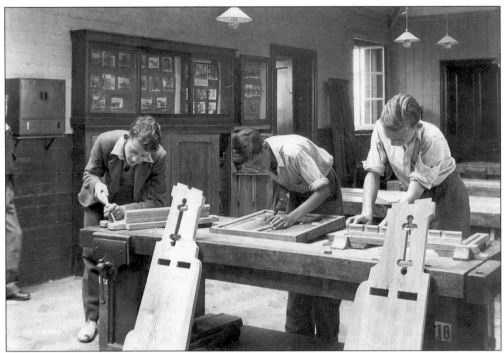

Three of the fourteen pupils who helped to make the lectern which was started in September 1948 and completed in July 1949.

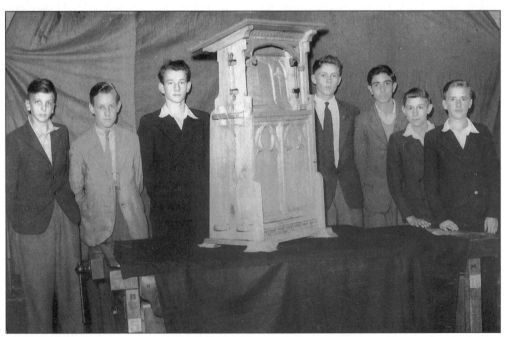

Pupils posed for this picture of the completed lectern which was designed by teacher Mr Harry Royson Tolley.

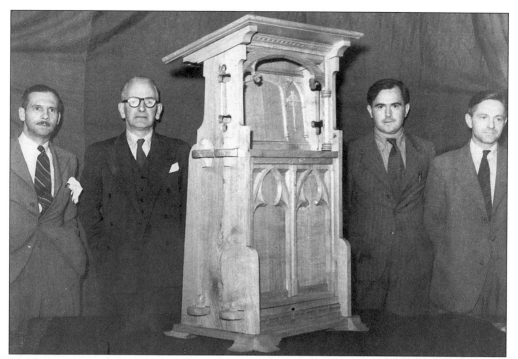

The boys practiced the intricate carvings on old pieces of wood before translating them to the selected oak. They worked under the guidance of Mr Harry Royson Tolley (first left), as well as Mr R. D. Treharne and Mr G. David who were the handicraft instructors at the school.

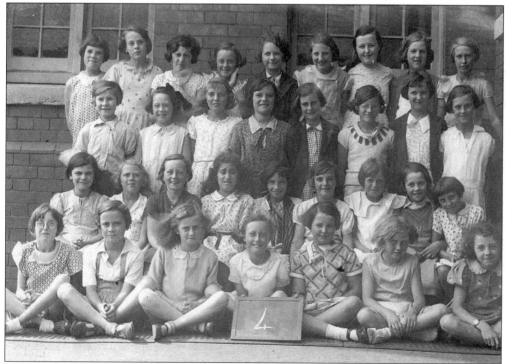

Standard 4, Gladstone Girls School, 1936.

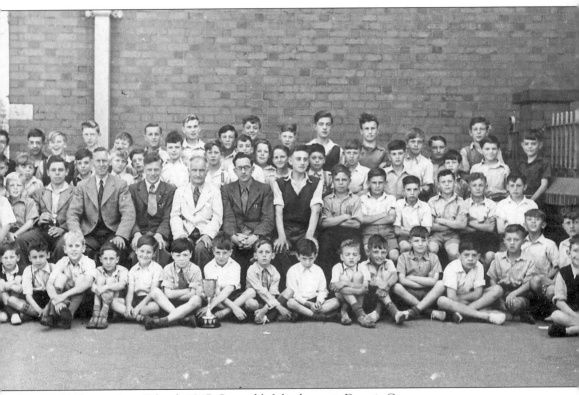

Gladstone Boys School, 1947. Second left back row is Dennis Carter.

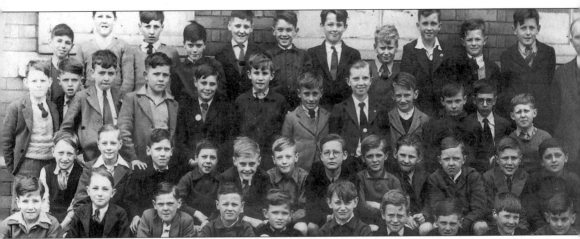

Gladstone Boys School, *c.* 1945. The boy third left front row is Billy Marks.

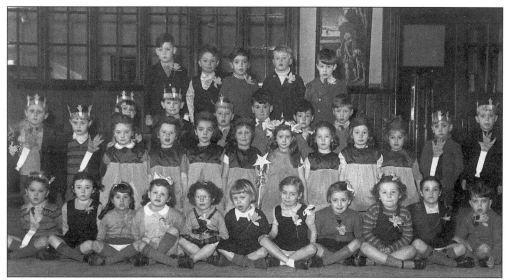

Pupils at Gladstone School celebrating St David's Day, *c.* 1948.

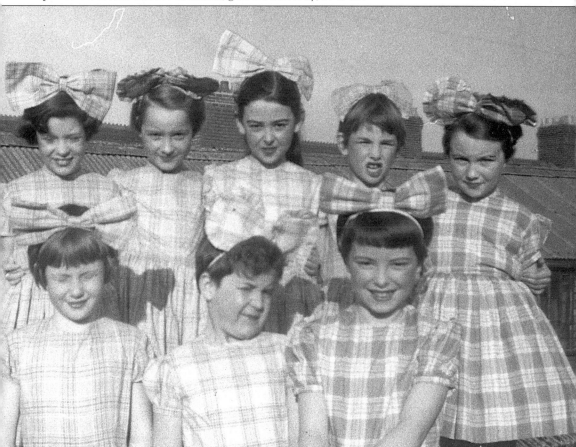

These children of St Joseph's Roman Catholic School took part in a concert, *c.* 1960. Among them are Margaret Bibey, Jennifer Stone and Margaret Plain.

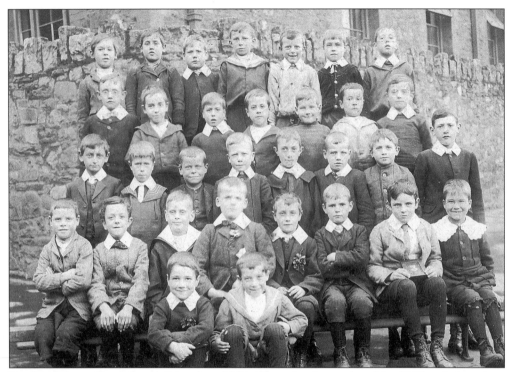

Pupils of Crwys Road Board School, *c.* 1908. The school was closed in 1939 and American soldiers were stationed there during the war. It later became the first home of the College of Food Technology and is now a supermarket.

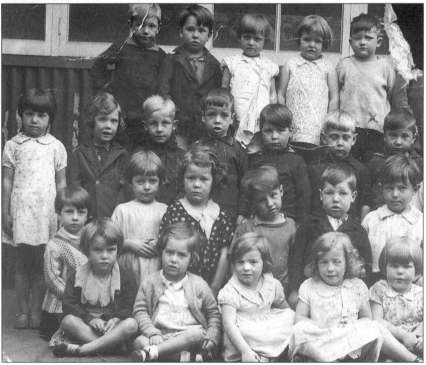

Crwys Road Board School, *c.* 1938. The boy extreme right top row is Douglas Wheeler who lived in Rhymney Street.

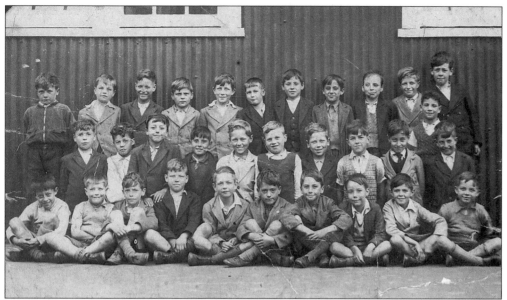

Maindy School, *c.* 1939. Left to right, included in the back row: Barry Blake, Leslie Belmont, ? Bailey, Danny Miller, ? Jenkins, Denis Virgo, ? Chugg, Alan Williams. Middle row: Glyn Jones, Roy Jones, Roy Ursell, -?-, -?-, ? Stephens, ? Vickery, Colstan Peters, ? Carpenter, ? Sparkes. Included in the front row, seated: ? Thomas, -?-, -?-, ? Lewis, ? Burrows, -?-, Malcolm Knapton is seated third from right.

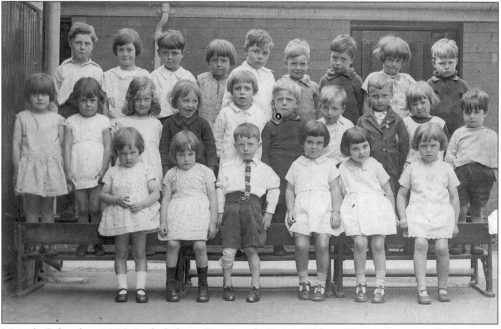

Maindy School, *c.* 1935. Included are: Roy Leach, Rene Gibbon, Dennis Lannon, Pat Lannon, Raymond Cox, Ronnie Ursell, Nancy Hewitt, Ernie Whittle, Betty Edwards, Gladys Jones, Eileen Morgan, Francis Pitt, Violet Ellaway, Raymond Clarke, Ronnie Free, Betty Page, Mary Crowley, Margaret Crowley, Peter Fisher, the Hancock twins and a boy named Jimmy. These are all people remembered by Tom Badman (also in this picture).

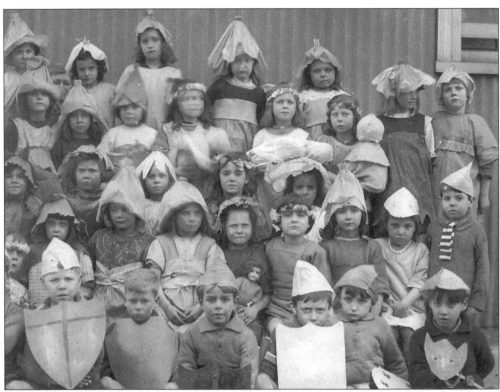

Saint David's Day, Maindy School, 1921. Second row up and third from the right is Susie Wood.

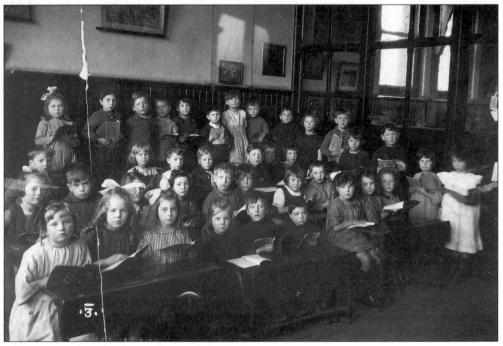

Class 3, Maindy School, c. 1920.

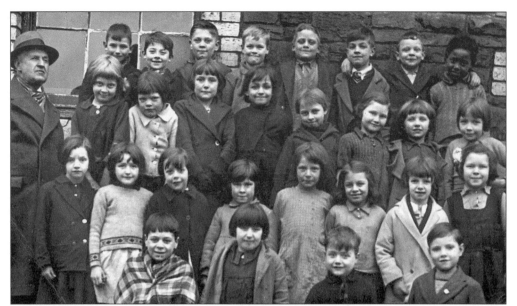

Cathays National School, *c*. 1940. Mr Ayres the headmaster can be seen left of the picture. The boy second from the left top row is Len Sidaway.

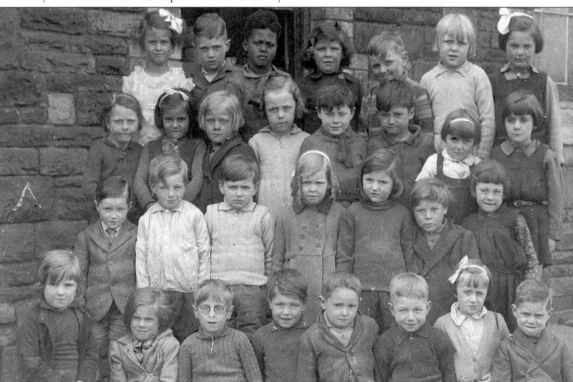

Cathays National School, *c*. 1943. Third from the left, second row from the back is Gloria Williams (née Gardner). First on the right, third row, is Margaret Sidaway. Mervyn Davies is third from the right, front row and Dennis Giggs, grandfather of Welsh soccer international Ryan Giggs, is on the extreme right front row.

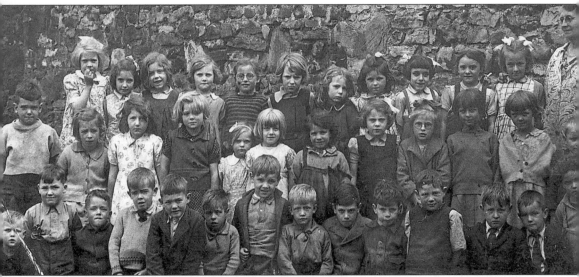

Class of 1944 at Cathays National School. The teacher extreme right is Miss Peggler and the well-dressed boy third from the right in the front row is Keith Colley who lived in Thesiger Street.

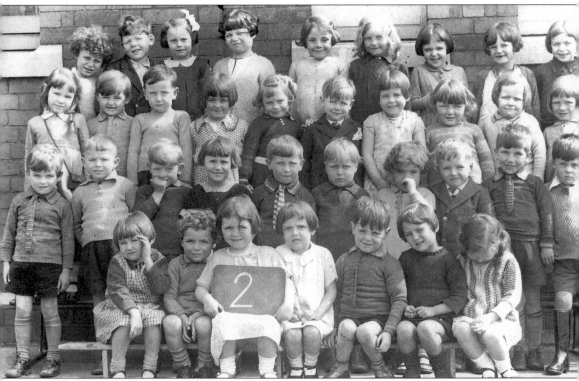

Gladstone School, Whitchurch Road, c. 1936. The school celebrated its centenary in 2000. Bill Barrett remembers: 'when the school opened in 1900, the first headmaster was Mr Kent whose nickname was Oddy. He was a no-nonsense disciplinarian and his task was a difficult one. Gladstone was a new school and pupils flocked to it in too great a number and classes of sixty pupils were the order of the day.'

Standard 5, Gladstone School, *c.* 1930. Gordon Goman who lived in Dalton Street is fifth from the left second row from the back. Others in the picture are: Fred Bryant, David Bailey, Bob Fortune, Alan Hancock, Bernard Ashman, Kevin Wainright, Albert Newman, Jack Jones, Gilbert Dwyer, Tecwyn Thomas.

Gladstone School, *c.* 1942. The teacher wearing a hat is Polly Davies. Among the pupils are: Dulcie Nicholas, Valerie Brummel, Barbara King, Eileen Thomas, Vera Harris, Joan Lewis, Jane Smith, Gladys Short and Eileen Howells.

Gladstone schoolgirls, *c.* 1951. Left to right. Josephine Cronin, Iris East, Jacqueline Bryant, Jennette Smith.

Gladstone School juniors, *c.* 1950. Left to right: Brian Sparks, Gloria Janicos, Oswald Hole, George Parfitt, Robert Gordon, -?-, Michael Buckley, Gillian Stamp, Gillian Coleman.

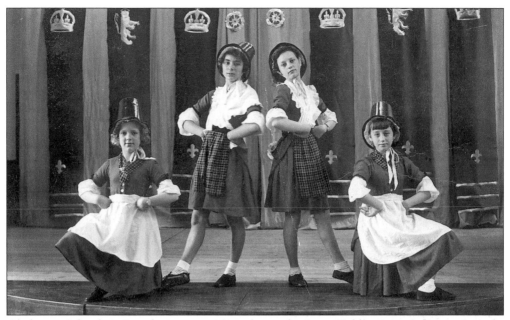

Gladstone School, St David's Day, *c*. 1953 Left to right: Joan Wakley, Joan Coleman, Jennifer Smith, Brenda Chamberlain.

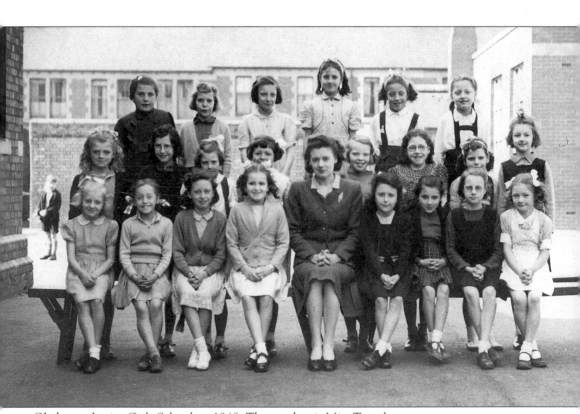

Gladstone Junior Girls School, *c*. 1948. The teacher is Miss Teasal.

Gladstone School, c. 1926. The teacher, second row from the back, extreme right is Miss George. The pupils include: Gordon Goman, Terry Saul, Billy Burgess, Olive Thomas, Doreen Williams, Pat Batchelor, Vivian Duggan, Marjorie Dunster, George Davies, Bernard Ashman, David Bailey.

Gladstone School sports team, c. 1966.

Gladstone School pupils, September 1966.

Karen Williams (wearing a cardigan) and
Heather Norey at Gladstone School,
September 1966.

Pupils of St Joseph's Roman Catholic School, *c.* 1958.

Standard 4, Allensbank Road Junior School, *c.* 1970. Left to right, back row: Andrew Spiers, Robert Cook, Steven Zeal, Robert Saunders, Robert Chivers, Ivor Pingue, Brian Williams, Mr Phillips (teacher). Middle row: Gary Price, David Lewis, Steven Lay, Russell Hughes, Steven Painter, Derick Curle, Raymond Clarke, Michael Curwin, Richard Salter. Front row: Tina Rice, Elizabeth Joyce, Karen Marshall, Jill Price, Christine Davies, Susan Macdonald, Barbara Davies, Lynne Macey, Catherine Howells, Lorna Spriggs, Catherine Millard.

Albany Road School, *c.* 1940. With the closure of Crwys Road School in 1939 many children from the Cathays area were sent to Albany Road School. Some of those in the above picture are: Glynn Parfitt, Sidney Caple, Tommy Coles, Raymond Porter, Margaret East, Albert Wakeham, John Warner and a boy with the surname of Booth.

Albany Road School, *c.* 1947. Extreme left, middle row is Glynn Parfitt whose father, Harry Parfitt, was the well-known scrap metal dealer.

Children of Standard 4 Gabalfa Junior School who took part in the play *Little Women* take a bow, *c*. 1958.

Pupils of Gabalfa Junior School posed for this picture in 1958. The headmaster, Trevor Charles, wrote on the back of the school photographs imploring his pupils to keep the following words in their hearts. 'I pass this way but once. If there is any good that I can do, let me not defer it, nor neglect it, but let me do it now, for I shall not pass this way again.'

Four
Special Occasions

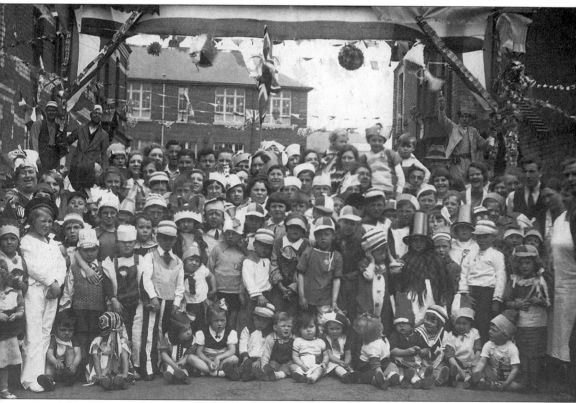

Residents of Flint Street got together to celebrate the Coronation of King George VI and Queen Elizabeth in 1937. Cathays High School can be seen in the background.

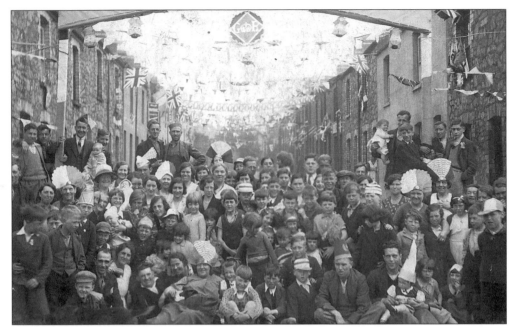

The Coronation celebrations for King George VI and Queen Elizabeth, only this time they are taking place in neighbouring Cross Street. The large lady wearing a paper hat and seated in the front of the picture is the street's matriarch Bessie Fergusson. Also in the picture is her son Jimmy, Ada Miller, Mrs Coles, Mrs Dunn, Mrs Lietch.

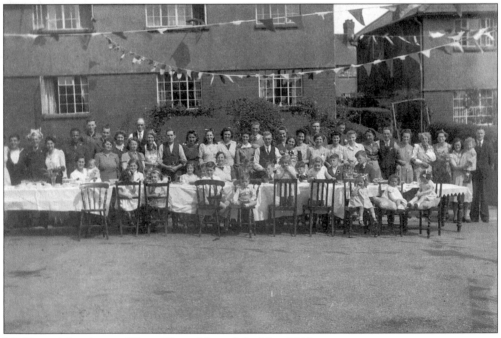

VE Day celebrations at Pilton Place, Mynachdy, May 1945.

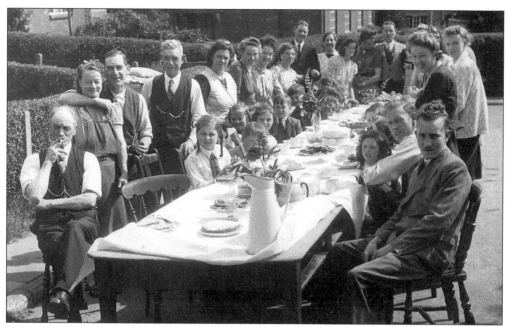

More VE Day celebrations at Pilton Place. Members of the Lewis, Free, Colwill, Adams and Badman families are somewhere in this picture.

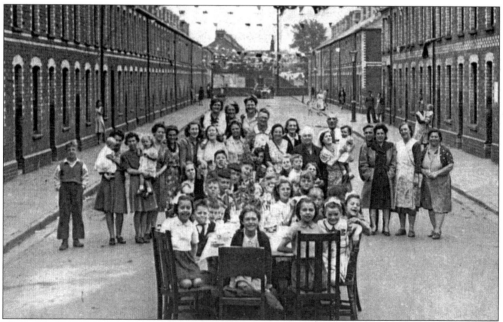

Rhymney Street residents celebrate the end of the war in Europe with a VE Day street party. The boy standing extreme left of the picture is Emrys 'Emo' Davies who served in the Korean War conflict some years later.

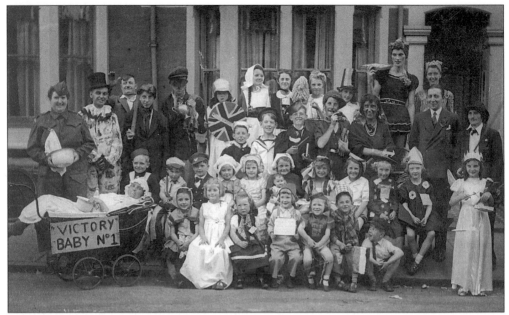

Cosmeston Street, Cathays, staged a fancy dress competition as part of their VE Day celebrations.

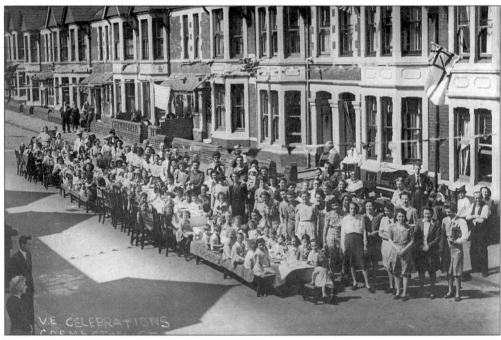

VE Day celebrations at Cosmeston Street. Note the piano in the front of one of the houses to the right of picture.

Three soldiers (one in civvies) from Gelligaer Street are given a 'Welcome Home' by their neighbours after the end of the Second World War. Standing in the centre of the above photograph and second, third and fifth from the right in the central group in the photographs below, they are: ? Cox, Stan Westacott and ? Woodfine.

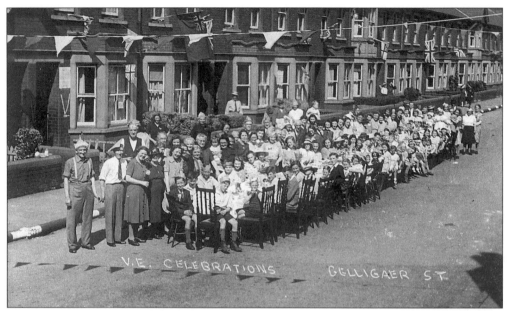

VE Day celebrations at Gelligaer Street, Cathays.

Merthyr Street residents celebrating the marriage of Queen Elizabeth II to Prince Philip in 1947. Tegwen Lewis, Margaret Mears, Pam Walters and Pauline Cork are just some of the children who joined in the celebrations.

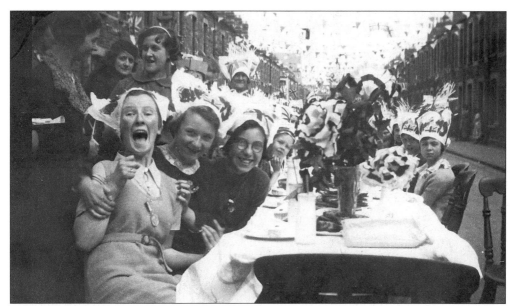

Residents of Flora Street, Cathays, celebrate the Coronation of King George VI and Queen Elizabeth, 1937. Seated left to right are: Jean Young, Mary Goman and Queenie Partridge. Also in the picture are Valerie Goss, Sylvia Coombes and Dulcie Nicholas.

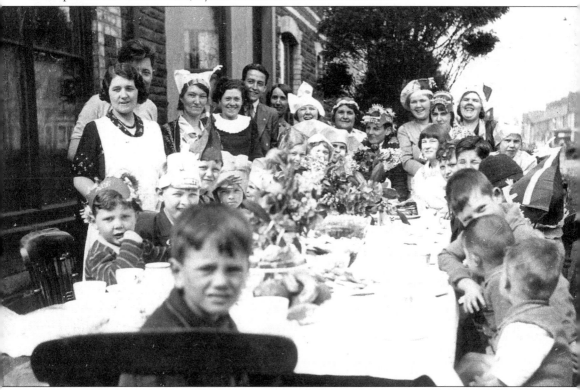

Celebrating the Silver Jubilee of King George V and Queen Mary in 1935 are these children who lived in Mundy Place. The party was held on the corner of Mundy Place and Richards Street.

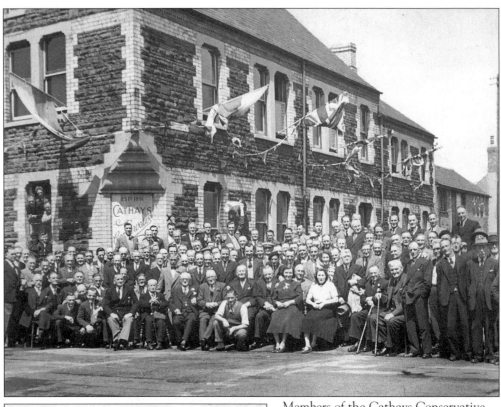

Members of the Cathays Conservative Club, Wyeverne Road, 1953. The club celebrated its centenary in 1991. It was officially opened by Lord Windsor on 10 October 1881.

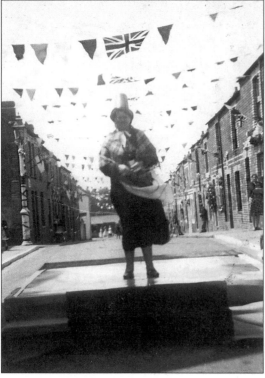

May Rice, of Flint Street, dressed in the Welsh national costume to celebrate the Coronation of Queen Elizabeth in 1953.

A children's street party was held in Robert Street, Cathays, as part of the Prince of Wales investiture celebrations in 1969.

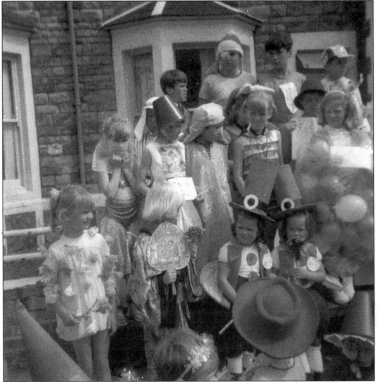

Harriet Street, Cathays, organized a fancy dress competition for the Prince of Wales investiture celebrations. The Ken Dodd Diddy people are Nichola and Natalie Richards. Also in the picture are Anne Vincent, Karen and Deborah Parfitt and the Toft sisters.

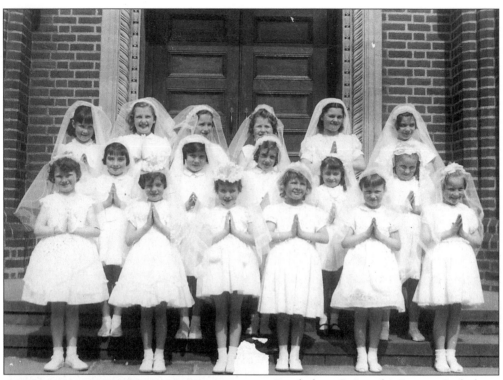

Pupils from St Joseph's Roman Catholic School on the occasion of their first communion. Marjorie Plain, Ann Grainger, Katherine Hobbs and Margaret Bibey are among them, 1958.

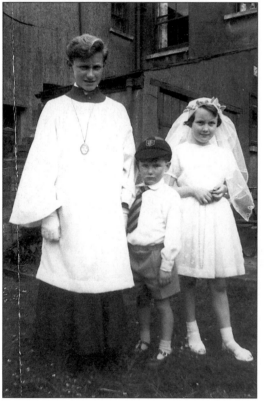

Bernard Plain with his brother Stephen and sister Margaret. Corpus Christi, c. 1960.

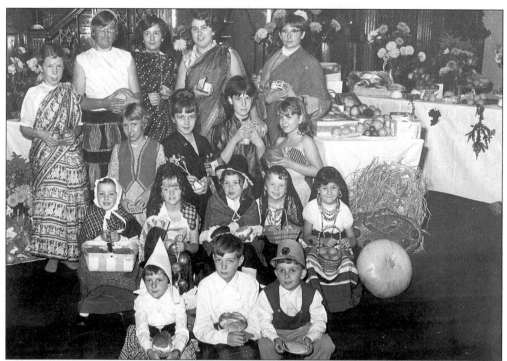

Woodville Road Baptist Church Harvest Festival, c. 1970. The little girl in the Welsh costume is Susan Toft.

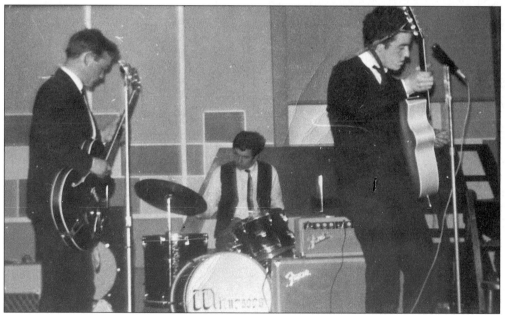

The Witnesses band playing at the twenty-first birthday party of Mynachdy's David Love in 1965. Left to right: Phil Morgan (driving bass), Richard Conant (slap-beat drums), Jeff Harrad (ace guitar). Phil Morgan recalled the venue: 'the social club hall on the south side of Western Avenue where we played was constructed from green corrugated steel and it disappeared when the avenue was widened in the sixties.'

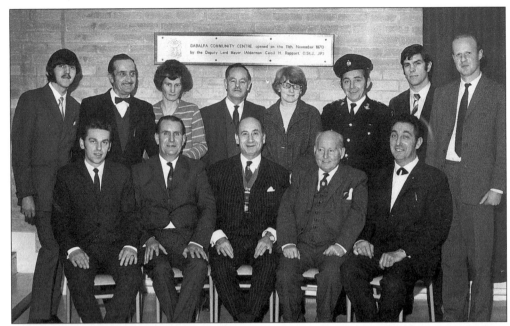

The Gabalfa Community Centre was opened on 11 November 1970 by the deputy Lord Mayor Alderman Cecil H. Rapport Order of St John, JP seen seated in the centre.

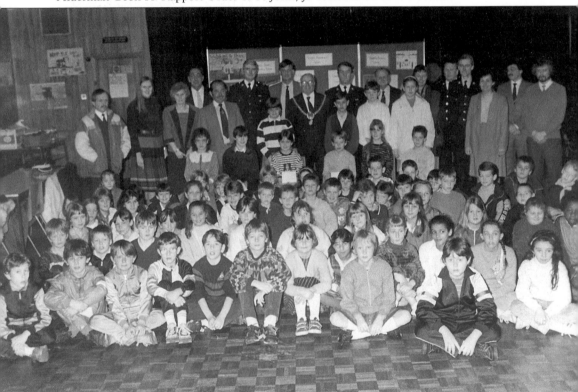

The Lord Mayor of Cardiff William Penry Herbert visited the Gabalfa Community Centre, in 1988, to present road safety slogan awards to local school children.

Programme for the Mynachdy Welfare Association Annual Fete and Gala Week, 18 July to 26 July 1930. Fancy dress competitions, a skittles tournament, a town crier's contest and whist drives were all part of the attractions.

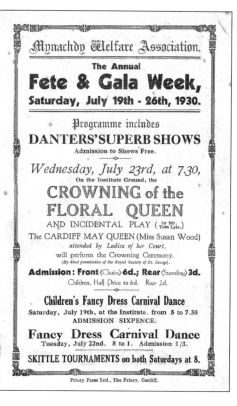

Mynachdy Welfare Association.

The Annual

Fete & Gala Week,

Saturday, July 19th - 26th, 1930.

Programme includes

DANTERS' SUPERB SHOWS
Admission to Shows Free.

Wednesday, July 23rd, at 7.30,
On the Institute Ground, the

CROWNING of the FLORAL QUEEN

AND INCIDENTAL PLAY (by Mr. Tom Lyle.)

The CARDIFF MAY QUEEN (Miss Susan Wood)
attended by Ladies of her Court,
will perform the Crowning Ceremony.
(By kind permission of the Royal Society of St. George.)

Admission: Front (Chairs) **6d.; Rear** (Standing) **3d.**
Children, Half Price to 6d. Rear 2d.

Children's Fancy Dress Carnival Dance
Saturday, July 19th, at the Institute, from 5 to 7.30.
ADMISSION SIXPENCE.

Fancy Dress Carnival Dance
Tuesday, July 22nd. 8 to 1. Admission 1/3.

SKITTLE TOURNAMENTS on both Saturdays at 8.

Priory Press Ltd., The Friary, Cardiff.

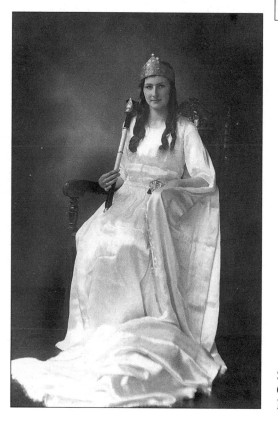

Susan Wood, aged thirteen, of Maindy Girls School, was elected Queen of the May for 1930/31.

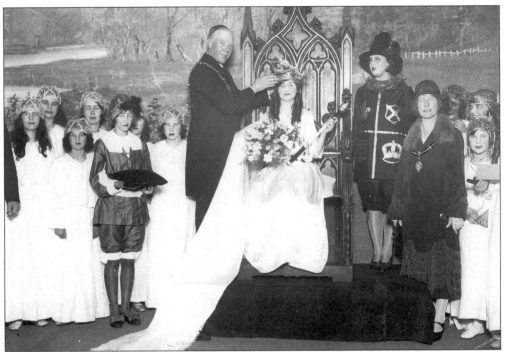

Susan Wood is crowned Queen of the May, on stage during a fairy play at the New Theatre, by the Lord Mayor Alderman William Charles JP.

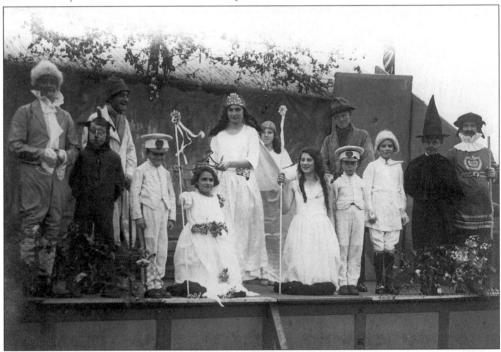

The Queen of the May, Susan Wood, on the float that led the big parade. She lived at 74 Mynachdy Road and competed against girls from sixteen other Cardiff schools to be elected the Queen of May.

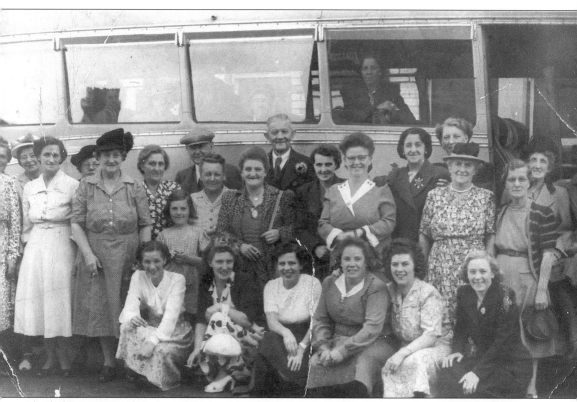

The ladies section of Cathays Conservative Club before setting out on a club outing, *c.* 1948.

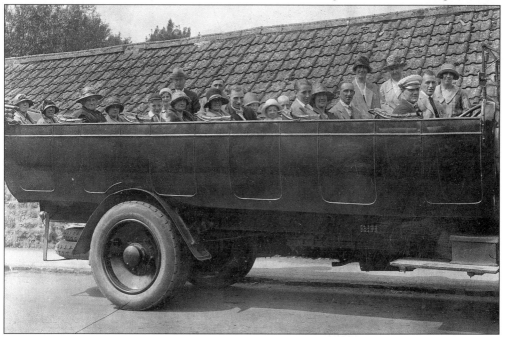

The year is 1926 and these residents of Maindy and Mynachdy are on a coach outing to the west country. The lady extreme right is Mrs Gladys Badman.

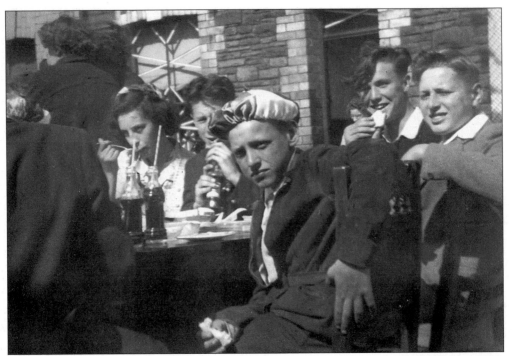

Children of Thesiger Street, Cathays, celebrate the Coronation of Queen Elizabeth II in 1953. Left to right: Barbara Statton, Keith Parkins, John Davey, Peter Hawkins, Keith Colley.

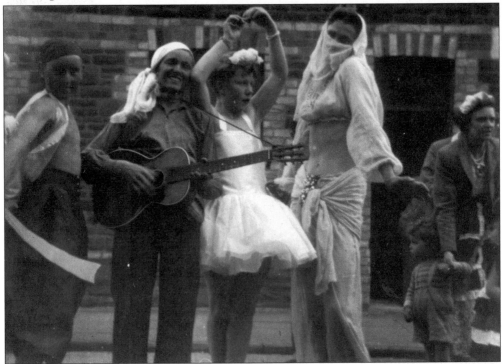

The fancy dress competition at a Coronation street party for Queen Elizabeth II on Thesiger Street. Left to right: Michael Murray, Keith Colley, Brynley Lawrence, Peter Hawkins.

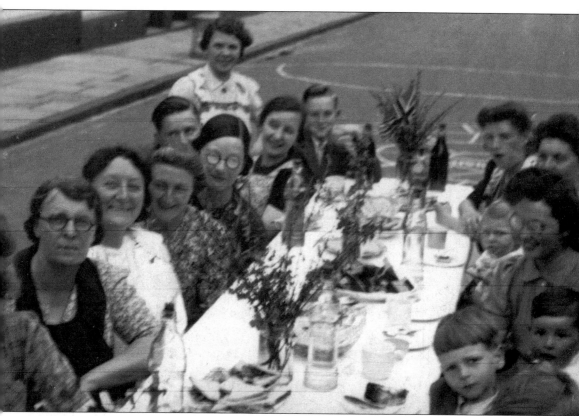

Florentia Street, Cathays, like most other streets in Cardiff celebrated the end of the Second World War with a street party.

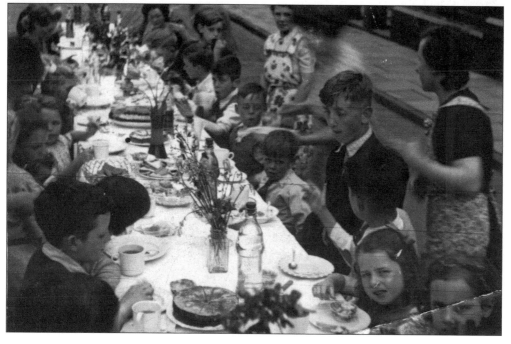

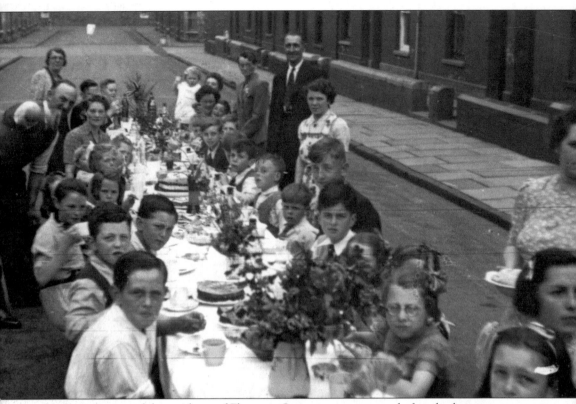

More pictures of the residents of Florentia Street in a party mood after the last war.

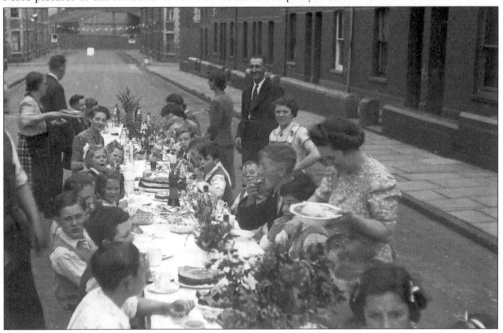

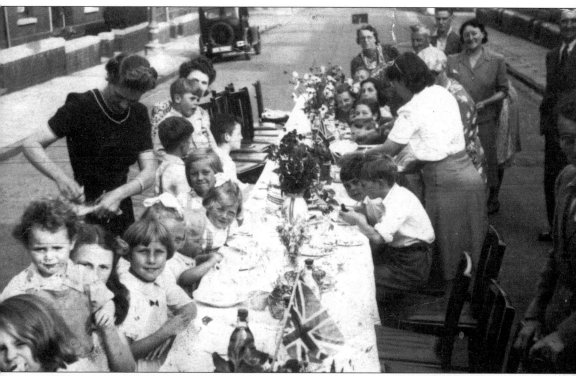

The VJ Day party on Florentia Street, 1945.

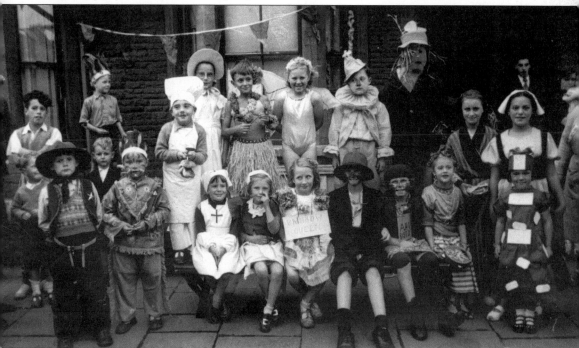

Children from Brithdir Street took part in a fancy dress competition as part of the Coronation of Queen Elizabeth II celebrations. The card around the little girl's neck reads 'Rainbow Queen'.

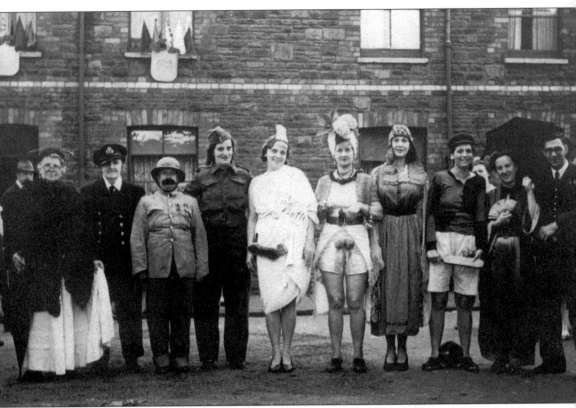

Minny Street celebrates the end of the Second World War. The lady dressed as a soldier is Maggie Turner. Mrs Melhuish is Carmen Miranda and the lady dressed in white is Rose Webber.

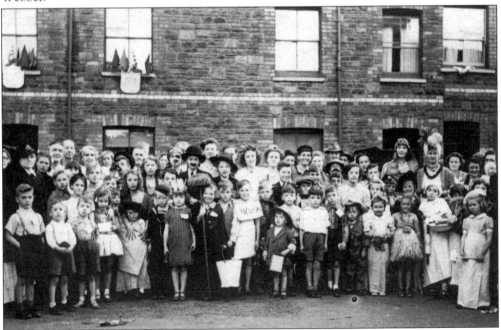

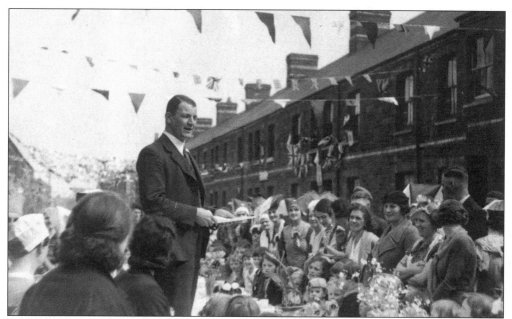

The gentleman, who appears to be giving the residents of Minny Street an end-of-the-war speech, is unfortunately unknown.

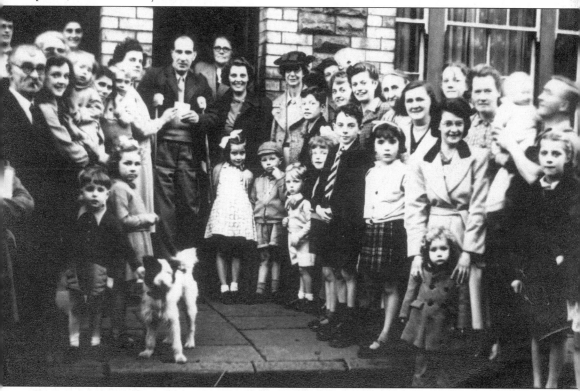

This picture, taken by L.G. Bennett who lived at 64 Minny Street, is just one of the many photographs he took of the after the war celebrations. The lady third right wearing the coat with black lapels is Mrs Phyllis Carter.

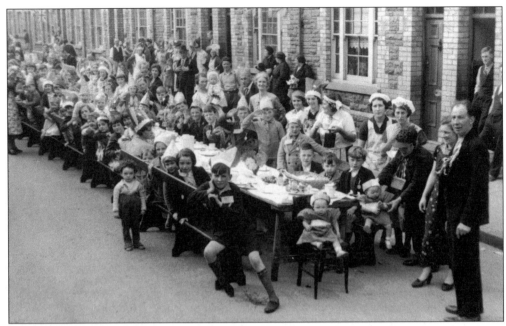

The children of Minny Street enjoy a sit down party to celebrate the war's end.

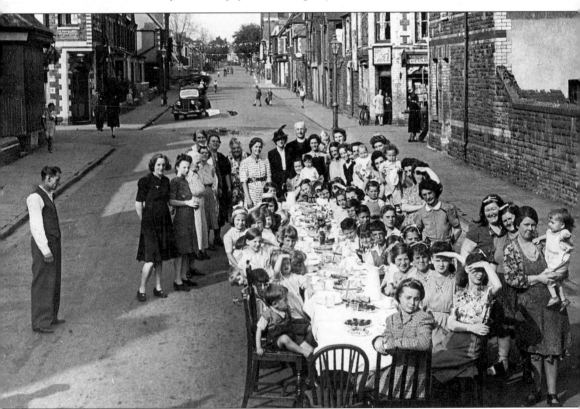

VE Day celebrations at Dalton Street, 1945. The grocery shop on the corner right of picture was run by Miss Drew.

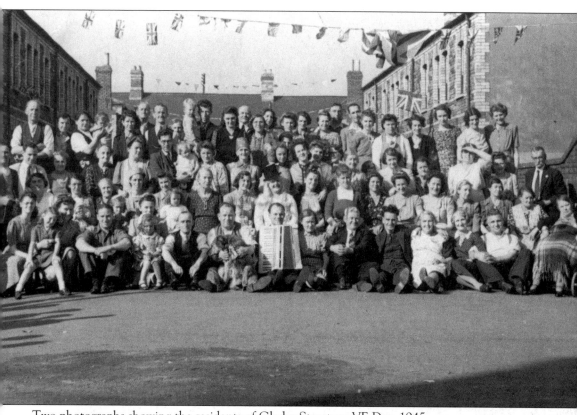

Two photographs showing the residents of Gladys Street on VE Day, 1945.

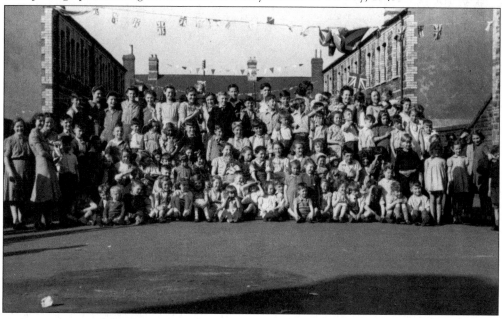

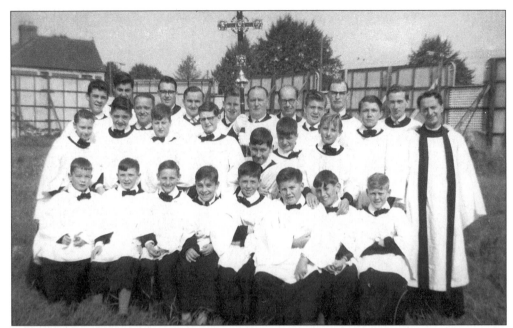

St Michael and all Angels Church choir, *c.* 1958. Left to right, back row: Bob Morgan, Mike Williams, Jack Williams, Eddie Davies, Idris Jones, Keith Parry, Charlie Edmunds, Doug Langley, Paul Porter, Carl Palmer, Colin Tucker, Revd Lawrence Miles. Middle row: Neil Williams, Ron Porter, Raymond Long, Colin Murdoch, Roger Hullah, Martin Underwood, Chris O'Brien, Roger Middleton. Front row: Michael Langley, Peter Middleton, Reggie Gill, Colin Sutton, ? Thomas, Ray Ormond, David Hullah, Robert Thomas.

In 1964 St Michael and all Angels Youth Club put on a Christmas dinner at the church hall for senior parishioners.

A nativity play was performed by members of St Michael and all Angels Youth Club in the church hall in 1960.

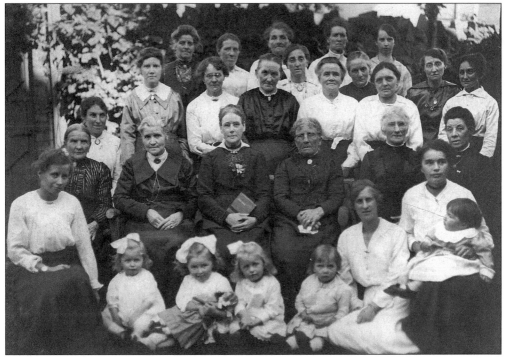

Dalton Street Methodist Sisterhood group, *c.* 1922. Jenny Dainton is the lady second row down extreme right. The lady holding the baby is Bessie Keeping (née Goman).

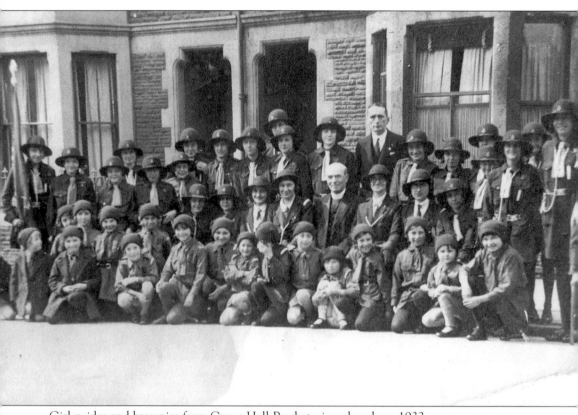

Girl guides and brownies from Crwys Hall Presbyterian church, *c.* 1932.

The girl guide seated extreme left is Edna Stockford (née Eggar). Third left seated is Lilian Dorwood (née Sloman) and to the right of her is Iris Eggar.

Lena Sloman, Alexander Rose Day, c. 1908.

The seven Sloman sisters from Tewkesbury Street, Cathays, 1912. Left to right are: Emily, Lena, Daisy, Georgina, Margaret, Lily and Gladys.

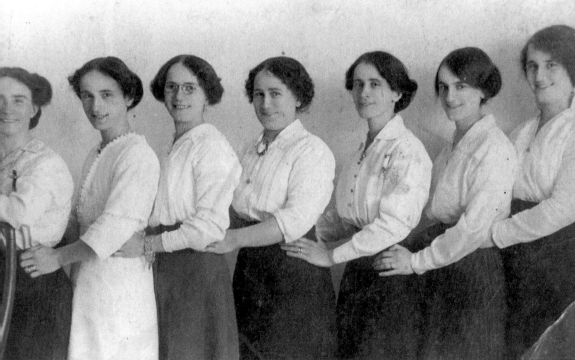

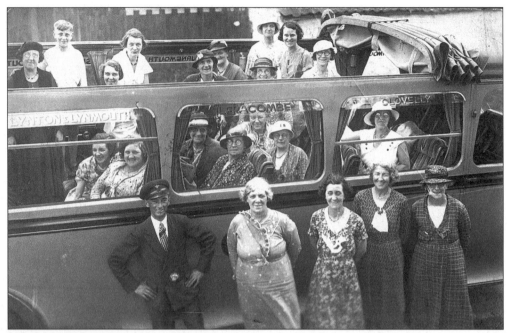

Crwys Hall Presbyterian Church Sisterhood outing to Cheddar, *c.* 1930.

Members of Cathays Liberal Club, 1953. The three ladies at the table right of picture are Mrs Spiller, Mrs Williams, Mrs Gardner.

The Union of Catholic Mothers, St Joseph's, Whitchurch Road, regularly put on stage shows in the 1960s.

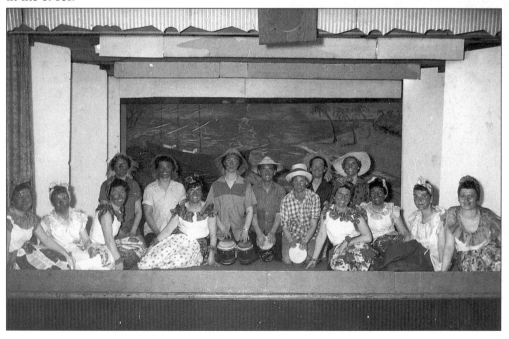

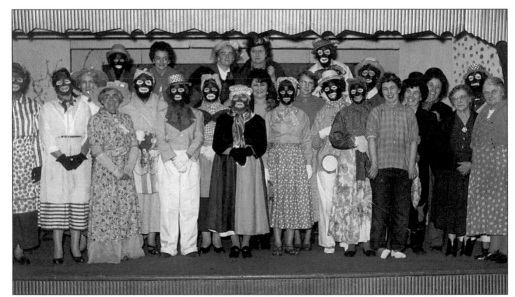

These days, Black & White Minstrel shows like the ones pictured here put on by St Joseph's UCM would probably be deemed politically incorrect. But, like the television show of the same name, they proved popular in the 1960s and 1970s.

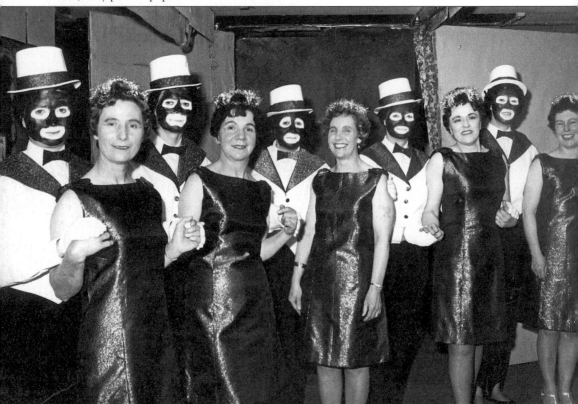

On the extreme right is Mrs Eileen Plain. Her children, Bernard, Stephen and Margaret are seen on p. 88 and her husband Bob is seen on p.25.

Five

Sport and Leisure

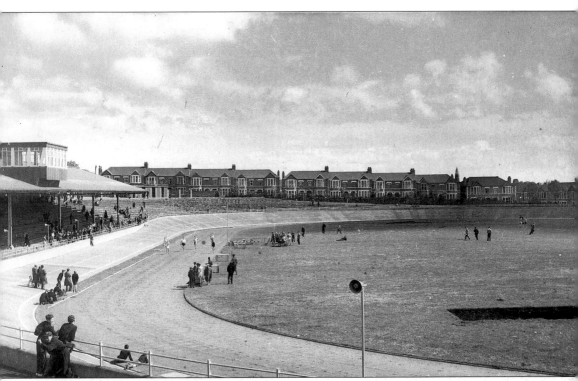

A tender of £4,145 to construct Maindy Stadium was submitted by Messrs J.P. Hennessey, Civil Engineering Contractors of Cardiff in 1948 and was accepted. Former world cycling champion Reg Harris said that the track was one of the best he had ever ridden on and his flying lap record (503 yards) of 27.8 seconds stood for some time. In the 1950s former Olympic sprinter Ken Jones covered 100 yards in even time (10 seconds) there, against a strong wind.

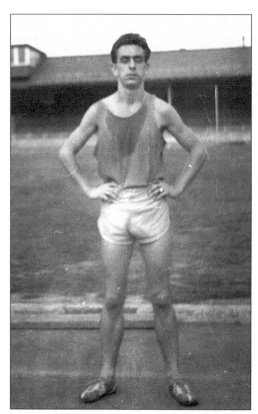

Author Brian Lee regularly trained at Maindy Stadium in the 1960s when the cost of a training session was sixpence and that included changing accommodation, the use of the track, and a shower!

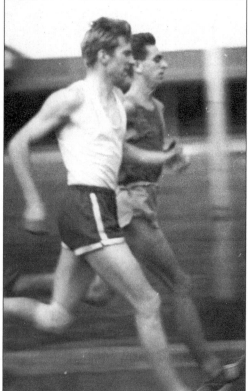

Malcolm Beames (wearing white vest) and Brian Lee during a training session at Maindy Stadium, *c.* 1966.

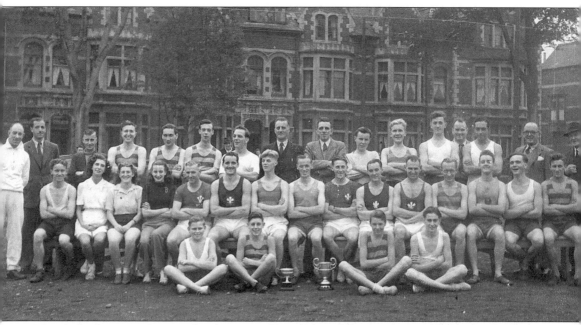

Maindy Stadium was the main headquarters of Roath (Cardiff) Harriers, but they sometimes used Roath Park recreation ground as this picture, taken in the late 1940s, observes. Seated seventh from the left, middle row is Alf Jensen, Maindy Stadium's sports officer for many years. Others in the picture include: Ted Hopkins, Eddie Cooper, Glyn Matthews, Ernie Virgin, Doug Mends.

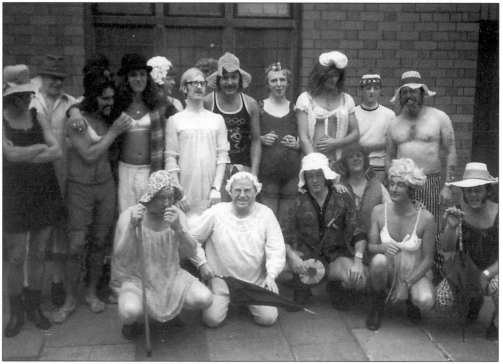

In 1982, a fancy dress charity walk competition was held from the Heath Hotel and regulars from the Gower, Crwys and Heath public houses took part. History does not record the winner!

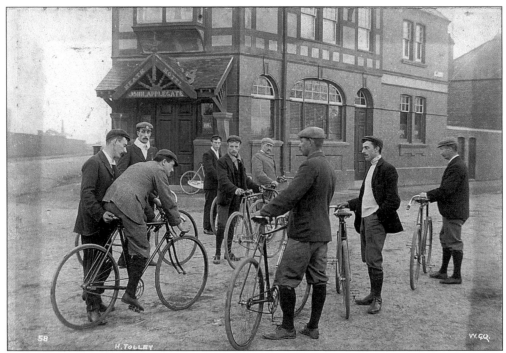

On 3 October 1898, Harry Tolley, starting outside the Heath Hotel in Whitchurch Road, completed a 200-mile road race and added to the Welsh cycling records a time not only for the 200 miles distance but for the 12 hours as well. He covered the 200 miles in 12 hours and 9 minutes and in 12 hours he rode 179 miles. The route took him through Newport, Caerleon, Raglan and Abergavenny and he finished at Pengam Bridge. Tolley, a founder member of the Cardiff 100 Miles Cycling Club, died aged seventy-four in 1947.

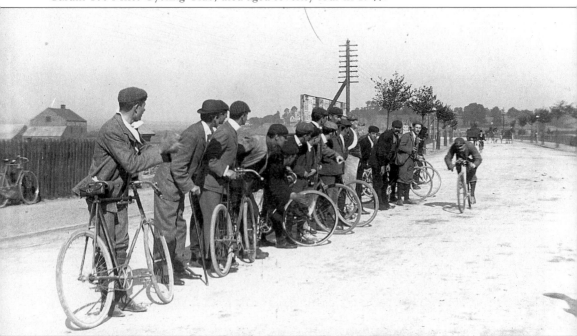

Glyn Matthews, captain of Roath (Cardiff) Harriers and a Welsh representative, is seen training at Maindy Stadium in 1956.

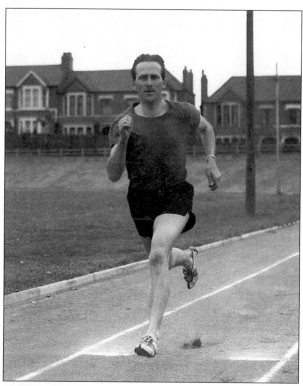

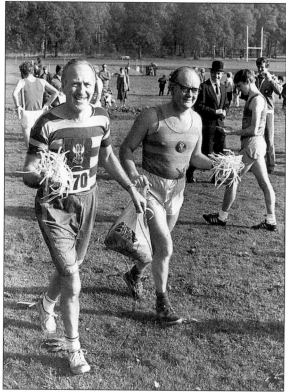

In 1982, Roath (Cardiff) Harriers, which had merged with Birchgrove Harriers in 1968 to become Cardiff AAC, celebrated their centenary year with an old fashioned paper chase cross-country race at Heath Park. To the left is Glyn Matthews with the Revd Bob Morgan. Also in the picture is Owen Edwards wearing a bowler hat and Norman John.

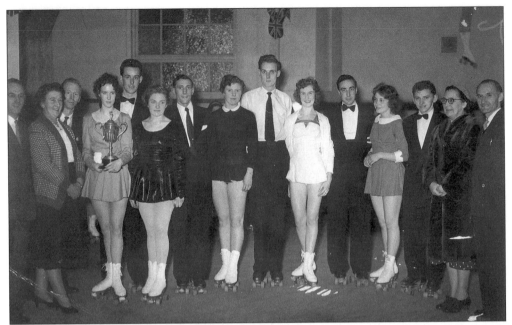

On 16 November 1958, the first Welsh National Roller Skating Dancing Championships were staged at the Cathays Terrace Roller Skating Rink. Left to right are: Dennis and Marion Bate (managers), Stan Hill (judge), Margaret and Ron Gibbs (London), Betsy and Cyril Sinclair (Southsea), Doreen and Peter Hicks (Rochester), Carol McLean and Trevor Roberts (Cardiff), Carol Smith and Brian Powell (Cardiff) Sybil Belcham (judge) and Jack Roberts (judge).

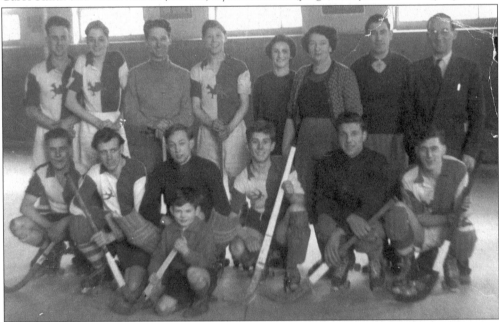

The Red Dragon and Cardiff Bluebirds roller skating hockey team, c. 1952.. Left to right, back row: Selwyn Hawkins, Glyn Davies, Peter Bosley, Haydn Davies, Sheilah Bate, Marion Bate, Ken Bryant, Dennis Bate. Front row: Dick Cottrell, Chad Chandler, Jackie Vaughan, David Parry, Johnny Powell, Johnny Haines. The boy in front is Tony Bate.

Members of the Cathays Falcon Wheelers Cycling Club posed for these pictures outside the City Hall, c. 1949.

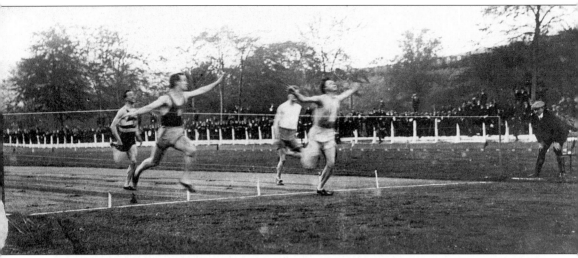

Tommy Oldfield (second left), who lived in Coburn Street, Cathays, won the world famous Welsh Powderhall Handicap Sprint at Taff Vale Park, Pontypridd, in 1911. After one of the closest finishes in the history of the race, Tommy Oldfield, a twenty-year-old Cardiffian, was declared the winner. But when the official announcement was made there were demonstrations of protest as a large section of the crowd were convinced that Alec Rowe, of Pontycymmer, had breasted the tape first.

Another Welsh Powderhall winner who came from Cathays was Eddie Williams who won the 1921 race. He is seen here with his sponsor, bookmaker Danny Davies. A master carpenter by trade, he ran his own business as a builder after the war building houses in the Rhiwbina and Whitchurch areas of Cardiff. He lived in Cwmdare Street, Cathays, until his death on 13 November 1959 aged seventy-two.

Harry Parfitt (extreme right) with the Welsh Amateur boxing team, Wrexham, c. 1960.

Harry Parfitt (right) at the May Day Cardiff Horse Show, Sophia Gardens, c. 1948. Rarely seen without a flower in his buttonhole, Harry Parfitt was a life member of the Welsh Junior Rugby Union and the only Welshman to be made a life vice president of the Amateur Boxing Association. A founder member of the Welsh ABA, he was an official at the 1948 London Olympic Games and at the 1958 Cardiff Commonwealth Games. He died in 1973 aged eighty-one.

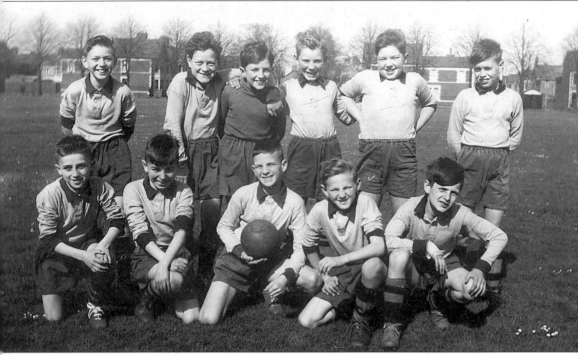

Gabalfa Juniors soccer team at Maindy Barracks fields, *c.* 1955. Roddy Jones, John Benson, Vince Hornsby, John Watts, Stuart Parry, Richard Jones, Bryn Rees and Ray Evans are just some of the young hopefuls.

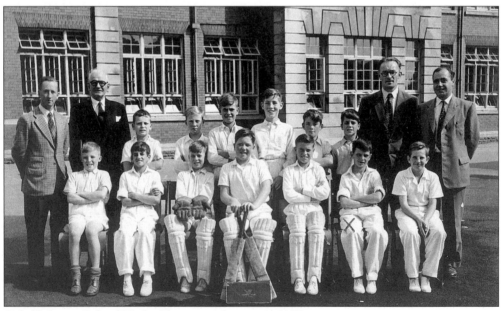

Gabalfa Junior School Under Elevens cricket team, 1957.

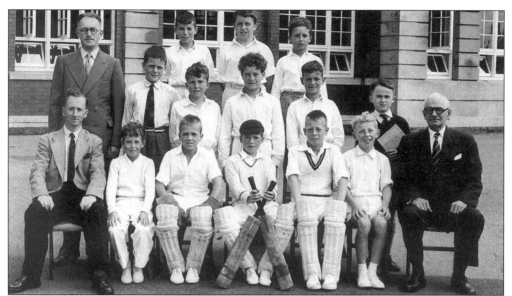

Gabalfa Junior School cricket team, 1958. Mr Charles the headmaster is seated right of picture.

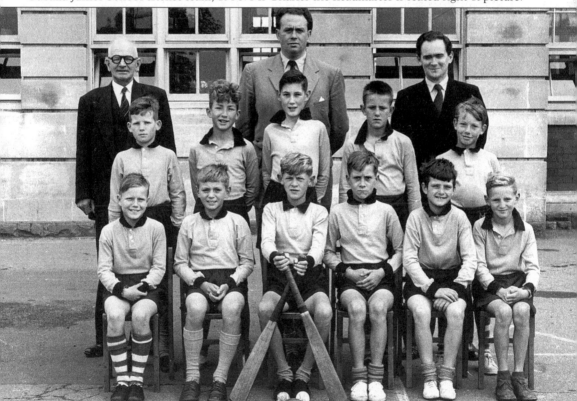

Gabalfa Junior School baseball XI who were finalists for the Stanbury Cup, 1956/57. Left to right, back row: Trevor Charles (headmaster), Mr C. M. Brown, Mr D. Lewis. Middle row: Robert Dowers, Denis Mackinnon, Robin Lay, Raymond Jones, Gwynfor Thomas. Front row: Russell James, Andrew Priest, Trevor Coombe (captain), John Stanworth, Raymond Evans, Paul Johns.

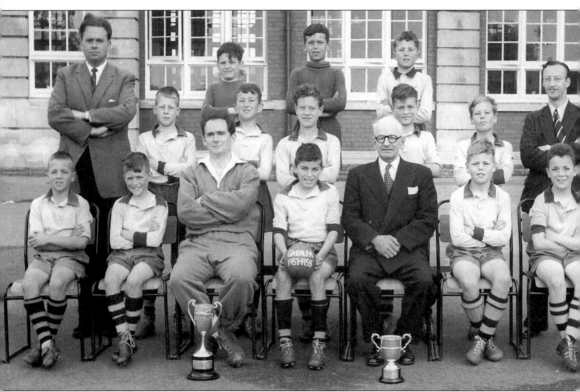

Gabalfa Juniors, 1957/58. They were Cardiff Schools Football League Junior Champions and Stanbury Cup Winners. Left to right, back row: E. Lee, E. Evans, R. Williams. Middle row: G. Brown, D. Rich, P. Maidment (vice captain) Rod Jones, J. Hill, D. John, Mr Hawkes. Front row: G. Rees, I. Knight, Mr Lewis, Richard Jones (captain), Mr Charles (headmaster), A. Elliott, N. Wells.

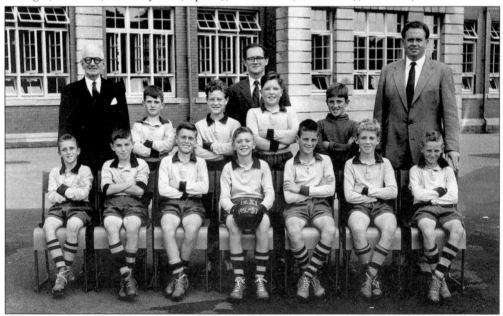

Gabalfa Junior School 1st XI soccer team, 1956/57.

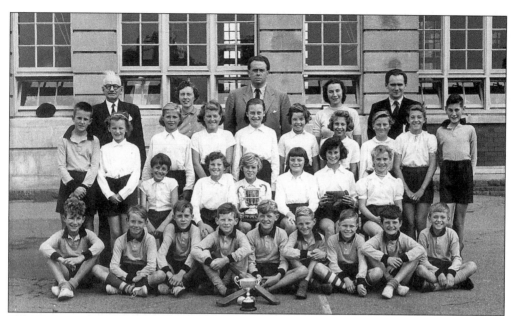

Gabalfa Junior boys and girls baseball teams, 1956/57.

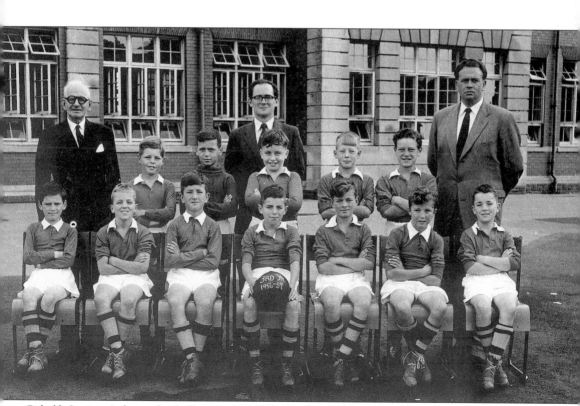

Gabalfa Juniors 3rd year football team, 1956/57. The boy holding the ball is Richard Jones.

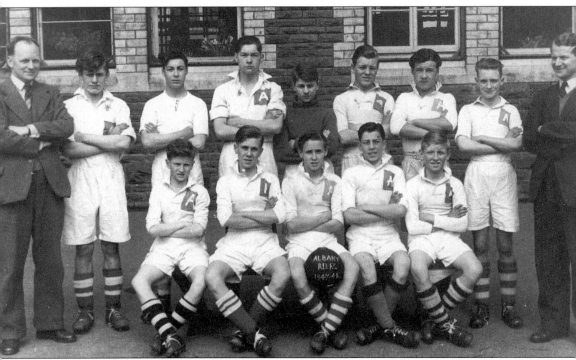

In 1948, Albany Road School beat Windsor Clive School 1-0 in the Seager Cup. Several Cathays boys were in the team and these included Jackie Cox seen holding the football and Glyn Parfitt (seated extreme right).

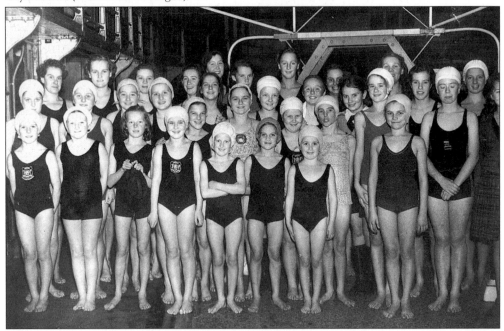

Daphne Holdsworth (née Jones) from Gabalfa (seventh from the left, front row) belonged to Cardiff Ladies Swimming club and at a swimming gala held at Guildford Swimming Baths she came third in the under 12s backstroke event on 2 October 1950.

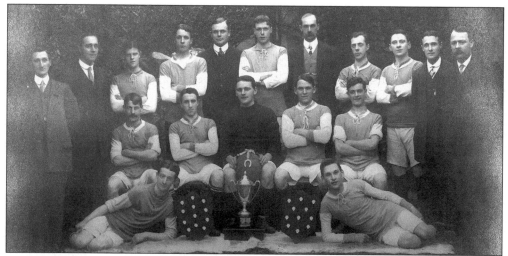

Cathays Wednesday Association Football Club, Wednesday League Champions and winners of the Lord Ninian Cup, 1911/12. Left to right, back row: F. Vale, C. Watts, G. Oldham, C. Reginald Harrison, W.J. Rumbelow, Mr O. Purnell (chairman), J. Daniels, J. Fearby, R. King, E. Arnold. Middle row: J. Jenkins, T. H. Tregarthen, T. O. Fearby (captain), A. E. Ashton, E. Comley. Front row: F. Naylor, H. Cooksley.

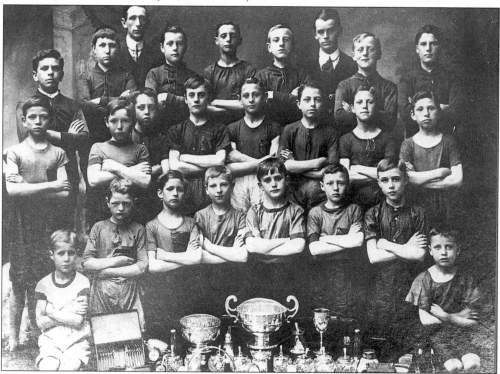

Gladstone School soccer team, 1916. The teacher at the back on the left is Ernie Phillips who taught all his working life at the school and the teacher to the right is Wilf Morris who later taught at Grange Council School. The boy in the centre of the picture (fourth from right, middle row) is Len Davies who went on to play for Cardiff City and Wales. He helped to score the winning goal when Cardiff City beat Arsenal in the 1927 FA Cup final.

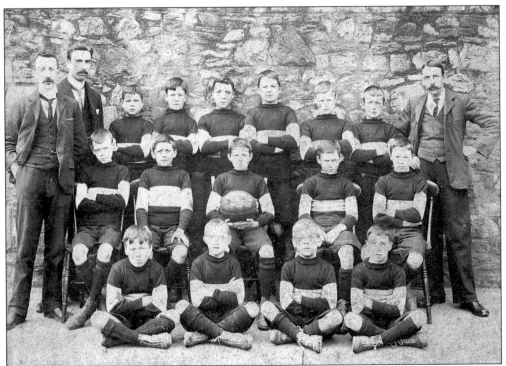

Crwys Road School football team, 1902/03. The boy in the back row first from the left is H.C.D. Harris of 26 Rhymney Terrace, Cathays, who served during the First World War as a lieutenant in the Mons Regiment Rifle Brigade. The photographer was Edward Ryan of 65 Wood Street, Cardiff.

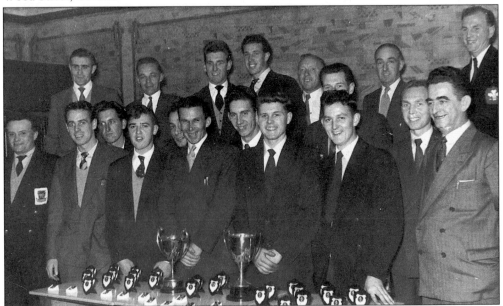

A presentation evening at the New Park Liberal Club for Roath Rangers football team, c. 1958. A number of Cathays boys played for the team and these included Glyn Parfitt, Terry Smith, Brian Davey, Jimmy Fish and Alan Paton.

This programme was designed by Fred Bryant who lived in Flora Street.

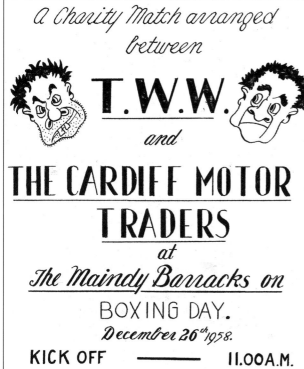

A charity football match was played on Boxing Day at the Maindy Barracks field between the staff of Television Wales & West and the Cardiff Motor Traders in aid of the Cardiff Motor Traders Remembrance Book Fund in conjunction with the Western Mail & Echo Appeal Fund.

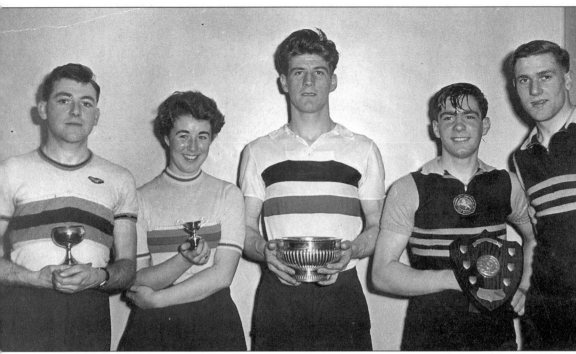

Maindy Stadium cycling champions, 1951. Left to right: Roy Attenborough, Ira Richards, Viv Randall, Ted Williams, Donald Poole.

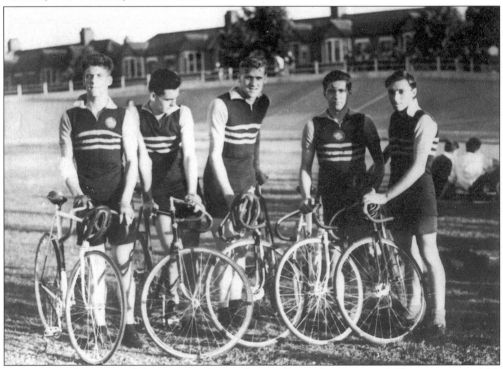

Unicorn Cycle Racing Club team members, 1951. Left to right: Viv Randall, Peter McDonald, George Jensen, Ted Wiliams, Donald Poole.

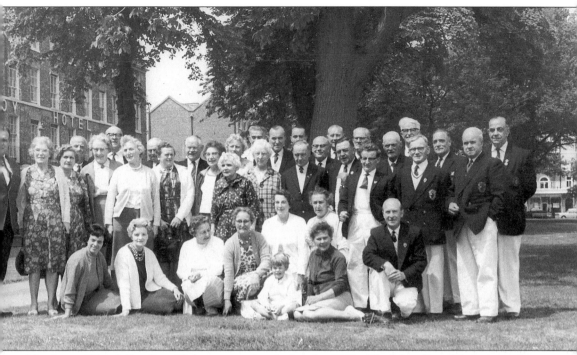

Members of Heath Bowling Club on an outing during the 1960s. Their bowling club is situated the north side of Maindy Stadium. The green was constructed in 1928 and proved so popular that a second green was laid in 1932. A bowls pavilion was built in 1934.

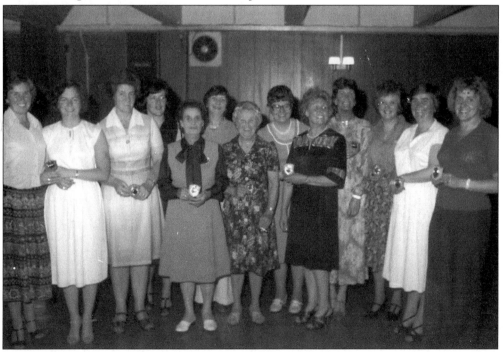

Maindy Hotel Ladybirds skittle team in the 1975/76 season. The lady extreme right is Gloria Williams (née Gardner) a former pupil of Cathays National School.

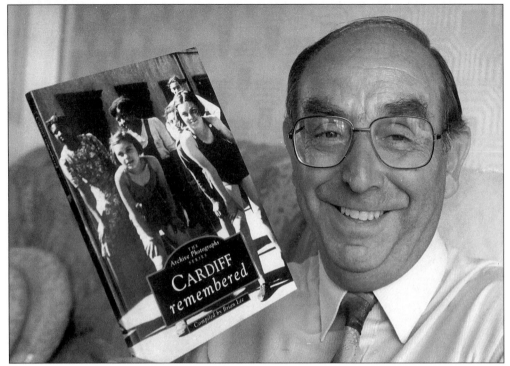

Author Brian Lee with his first book in the *Archive Photographs* Series, Cardiff remembered.

Acknowledgements

I am greatly indebted to the following people who loaned me their precious photographs. Without their help this second selection could never have been compiled. Dennis Carter, Colin Duggan, Joan Burnell, Ralph Rees, Tegwyn Hugglestone, Monica Walsh, Dulcie Vincent, Sheilah Davies, Robert Summerhayes, Glyn Parfitt, Margaret Baldwin, Tom Badman, Val Croot, Eileen Plain, Gillian White, Colin Merrick, Marion Jenkins, Gordon Goman, Richard Jones, Jean Hicks, Jack Sullivan, Marilyn Tipples, Trica Gibblet, Allen Hambly, Emily Donovan, Keith Colley, Pat Treasure, Mrs Hicks, Vic Wheeler, Malcolm Knapton, Beverley Williams, Gloria Williams, Mrs Hewitt, Mrs Porter, Joan Mabbs, Vera Mabbs, Sid Eggar, Freda Webber, Maldwyn Davies, Ray Evans, Ted Williams, Mrs Evans, P. Coombes, Philip Gardner, Russell Harvey and Maureen Ashfield.

Special thanks go to Emma James of the South Wales Echo for writing the foreword. Others I need to thank are the editors of Western Mail & Echo for publishing my requests for photographs and especially Bill Barrett of the Cardiff Post for his continued support. I would also like to convey my appreciation to my Project Editor Jane Friel for her help and my publisher Tempus for giving me the opportunity to compile this second selection. Finally, I would also like to thank those people who offered photographs which, for one reason or another, were not used and ask forgiveness of any contributor who may have been inadvertently omitted from these acknowledgements.